Piggy Banks

SALVADANAI

Savi Arbola

Marco Onesti

CHRONICLE BOOKS

SAN FRANCISCO

First published in the United States of America in 1994 by Chronicle Books.
Copyright © 1992 by BE-MA Editrice.

Printed in Hong Kong.

Library of Congress Cataloging-in-Publication Data:

Arbola, Savi.
 [Salvadinai. English]
 Piggy Banks = Salvadinai / Savi Arbola, Marco Onesti ;
 [photography, Tony Fedeli].
 p. cm. — (Bella cosa)
 Text in English; captions in English and Italian.
ISBN 0-8118-0779-7
1. Coin banks—History—19th Century. 2. Coin banks—History—20th century.
3. Coin banks—Catalogs.
I. Onesti, Marco. II. Title. III. Series.
NK4698.A7313 1994
688.7'2—dc20 93-48641 CIP

Caption translation: Joe McClinton
Photography: Tony Fedeli
Cover photograph: Tony Fedeli
Cover and text design: Dana Shields, CKS Partners, Inc.
Production: Robin Whiteside

Distributed in Canada by Raincoast Books
112 East Third Avenue
Vancouver, B.C. V5T 1C8

10 9 8 7 6 5 4 3 2 1

Chronicle Books
275 Fifth Street
San Francisco, California 94103

Piggy Banks

A tiny family safe, or an educational toy for children—the long history of the piggy bank is closely linked with the invention and saving of money itself.

This illustrated collection offers a broad selection of some of the world's finest and most popular banks, from the terra-cotta still models widely used by poorer families to miniature bank safes and even more sophisticated designs with combinations and complex movements.

The examples presented here, made in different periods and from a variety of materials, help illustrate not only why the piggy bank is still valued as a gift by adults and children alike, but also why it has attracted the attention of collectors. As it has with many other so-called minor objects of folk art, collecting has encouraged the preservation of piggy banks and facilitated the documentary reconstruction of their history and their evolution.

 \mathscr{A} pot-bellied still bank of turned wood, reminiscent of a crying child's face. Opened by removing an external padlock and unscrewing the base.

Italia, primi '900
Salvadanaio statico a forma panciuta in legno tornito, ricorda il viso di un bimbo che piange.
Apertura: sulla base si svita dopo aver tolto lucchetto esterno.

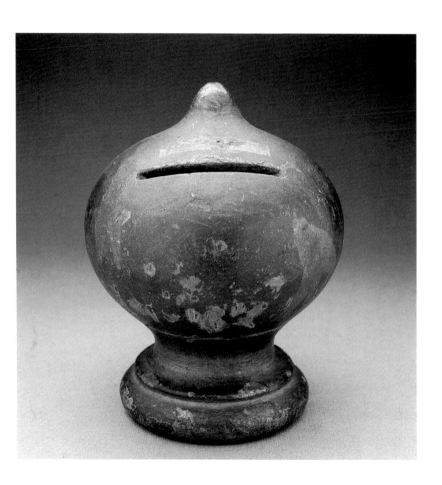

𝒜 classic jar-shaped terra-cotta bank from southern Italy. Opened by breaking.

Italia, primi '900
Salvadanaio statico in terracotta classico dell'Italia meridionale a forma di giara.
Apertura: rottura salvadanaio.

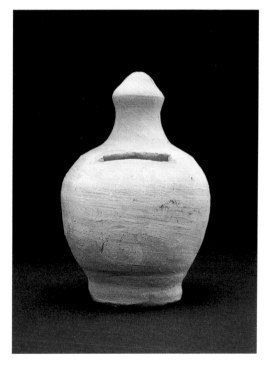

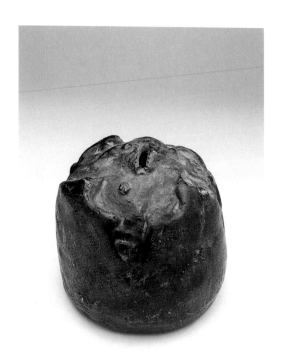

\mathcal{T}his terra-cotta still bank shaped like a
panettone, the well-known Milanese sweetbread, was
used to save up money for Christmas. Opened by
breaking.

Italia, primi '900
Salvadanaio statico terracotta a forma di panettone,
tipico dolce milanese. Veniva usato per risparmiare i
soldi da utilizzare nelle festività natalizie.
Apertura: rottura salvadanaio.

Italy,

EARLY 20ᵀᴴ CENTURY

A terra-cotta still bank depicting the Piedmontese folk character Gianduia. Opened by breaking.

Italia, primi '900
Salvadanaio statico in terra-cotta—tipica maschera piemontese "Gianduia". Apertura: rottura salvadanaio. ➤

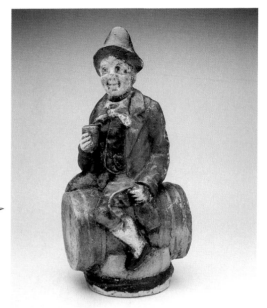

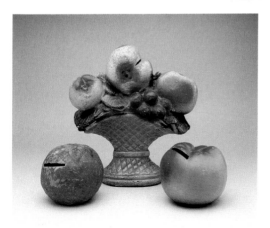

Terra-cotta still banks, commonly used by the peasants of northern Italy. Opened by breaking.

Salvadanai statici in terracotta, molto usati nel Nord d'Italia dalle popolazioni contadine. Apertura: rottura salvadanaio. ◄

Europe,
CIRCA 1910

\mathscr{A} terra-cotta still bank shaped like a rich man in blissful repose. Opened by breaking.

Europa, 1910 circa
Salvadanaio statico in terracotta raffigurante un ricco signore che riposa beatamente.
Apertura: rottura salvadanaio.

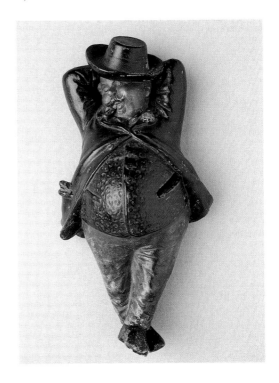

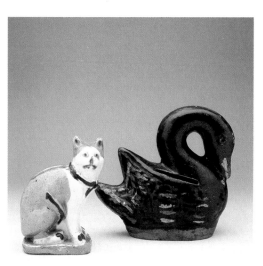

Northern Europe and Germany,

EARLY 20TH CENTURY

Terra-cotta still banks shaped like animals. Opened by breaking.

Nord Europa e Germania, primi '900
Salvadanai statici a forma di animaletti—terracotta. Apertura: rottura salvadanaio.

◄

Czechoslovakia,

EARLY 20TH CENTURY

A terra-cotta still bank depicting Ferda the ant, a character in children's fables. Opened by breaking.

Cecoslovacchia, primi '900
Salvadanaio statico in ceramica, raffigurante la formica "ferda", nota protagonista di fiabe per bimbi. Apertura: rottura salvadanaio. ►

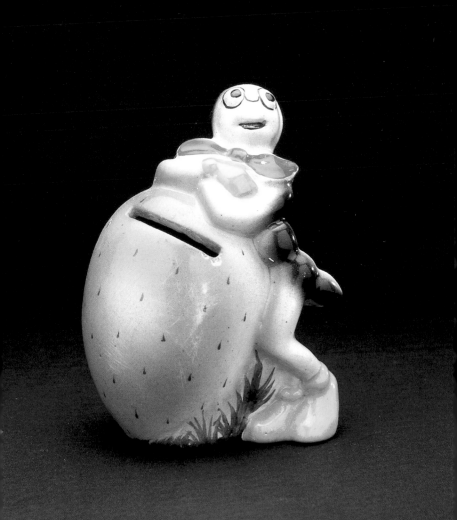

Hungary,

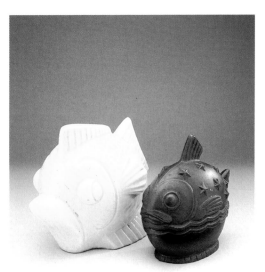

\mathcal{A} valuable bank shaped like a tower. Opened by breaking.

Ungheria, primi '900
Pregevole salvadanaio a forma di torre.
Apertura: rottura salvadanaio. ➤

Europe,

EARLY 20ᵀᴴ CENTURY

\mathcal{T}wo art deco fish still banks. The one on the left is opened by breaking, while the one on the right has a key-operated hinged door underneath.

Europa, primi '900
Due pesci art deco. Salvadanai statici.
Apertura: salvadanaio a sinistra a rottura, a destra sportello a chiave sulla base.
◄

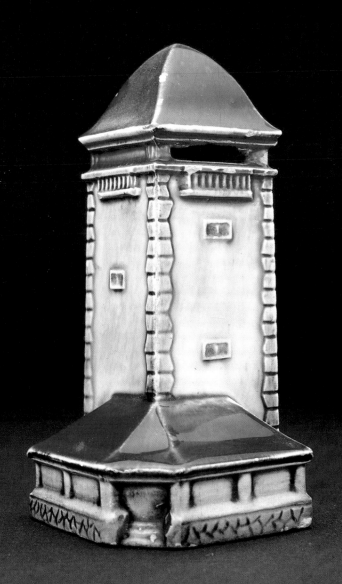

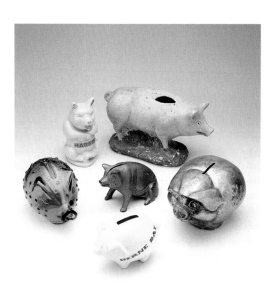

Europe and U.S.A.,

LATE 19ᵀᴴ–EARLY 20ᵀᴴ CENTURY

Genuine piggy banks of various materials (ceramic, aluminum, cast iron, and glass), depicting one of the best-known symbols of the prosperity generated by saving.

Europa e U.S.A., fine '800–metà '900
Gruppo di maialini. Salvadanai di diversi materiali (terracotta, ceramica, alluminio, ghisa, vetro) raffiguranti uno dei simboli più comuni del benessere creato dal risparmio.

U.S.A.,

1950

Models handed out by American banks. Both have an opening in the base.

U.S.A., 1950
Salvadanai degli anni '50, distribuiti dalle banche U.S.A.
Apertura: portellino sulla base. ➤

U.S.A.,
1 9 3 0 – 3 6

A "wise pig" cast-iron still bank by Hubley. Note the inscription. Opened by unscrewing a cover on the pig's back.

U.S.A., 1930–36
Il maiale saggio della Hubley.
Salvadanaio statico, fusione in ferro.
La filastrocca dice:
risparmia un penny ieri
un altro risparmialo oggi
domani un altro ancora
per tenere il lupo lontano.
Apertura: a vite sulla schiena.

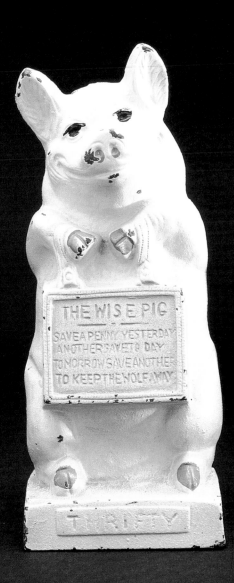

THE WISE PIG

SAVE A PENNY YESTERDAY
ANOTHER SAVE TO DAY
TOMORROW SAVE ANOTHER
TO KEEP THE WOLF AWAY

THRIFTY

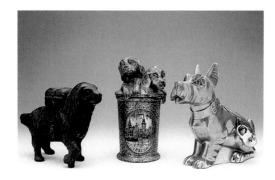

\mathcal{A} group of dogs:

A Saint Bernard with pack, U.S.A., A.C. Williams Company, 1905–30, cast iron.

Dogs in a basket, Switzerland, early 1900s, metal alloy.

Art deco Scottie, Germany, around 1935, nickel.

U.S.A., primi '900
Gruppo di cani.
S. Bernardo con pacco. "A.C. Williams"/U.S.A.
1905–1930/Fusione in ferro.
Cani nel cestino/Svizzera, primi '900/Lega.
Scottie, Art Deco/Germania circa 1935/Nikel.

England,
CIRCA 1911

\mathcal{B}ears on hind legs by John Harper & Co. Ltd.
Still banks of various materials: cast iron, aluminum,
and alloy. Opened by unscrewing a cover on the back.

Inghilterra, 1911 circa
Orsi in piedi della John Harper & Co. Ltd.
Salvadanai statici in diversi materiali: fusione in ferro,
alluminio, lega.
Apertura: a vite sulla schiena.

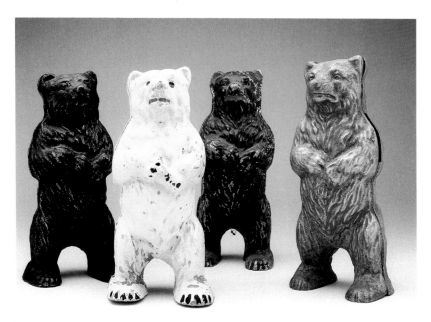

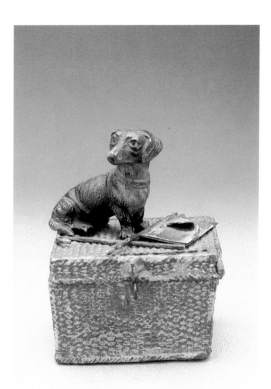

A still bank made of lead, with a little dachshund, walking stick, and briefcase. Opened by removing a padlock on the lid of the basket.

Europa, 1910–30 circa
Salvadanaio statico in piombo raffigurante un piccolo cane bassotto con bastone da passeggio e cartella da lavoro. Apertura: con lucchetto posto sul coperchio del cesto.

A still bank made of lead that locks with a pad-lock. The coin slot is on the cat's head.

Germania, primi '900
Salvadanaio statico in piombo. Introduzione delle monetine dalla testa del gatto. Apertura: con lucchetto. ➤

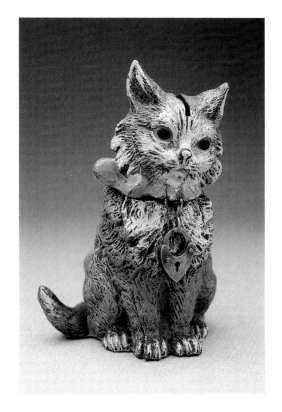

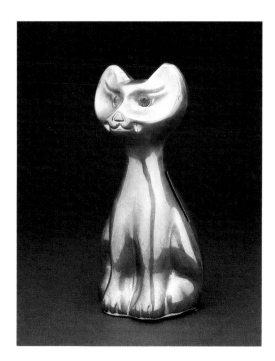

Northern Europe,

CIRCA 1950–60

A still bank made of metal alloy. Opened through a locking hinged door underneath.

Nord Europa, 1950–60 circa
Salvadanaio in lega—statico. Apertura: con sportello e serratura sotto la base.

≺

Germany,

EARLY 20ᵀᴴ CENTURY

*A*n elephant sitting on a circus stool, metal alloy.
A little elephant made of lead. Openings are on the head and under the blanket on the back, respectively.

Germania, primi '900
Salvadanai statici. Elefante seduto su sgabello da circo, realizzato in lega. Elefantino in piombo. Apertura: sulla testa e sotto la coperta sulla schiena. ➤

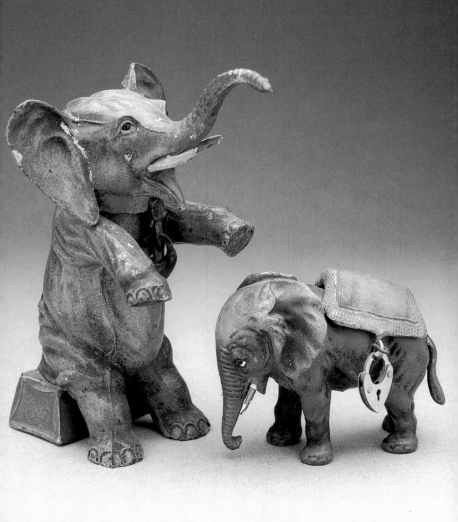

England, U.S.A., and Germany,

EARLY 20ᵀᴴ CENTURY

*S*till banks:

An elephant beating a drum, metal alloy. Opened by unscrewing a cover underneath. England, Arthur Shaw & Co., 1933.

Cast-iron elephant with howdah. Opened through padlocked door on the elephant's back. A.C. Williams Company, U.S.A., 1934.

Metal alloy elephant. Opened through padlocked door on the elephant's back. Germany, early twentieth century.

Inghilterra, U.S.A. e Germania, primi '900

Elefante che suona il tamburo, lega. Apertura: a vite dalla base. Arthur Shaw & Co. Inghilterra 1933.

Elefante con portantina/Fusione ferro. Sportello con lucchetto sulla schiena. A.C. Williams U.S.A. 1934.

Elefante/Lega.

Sportello con lucchetto sulla schiena. Germania, primi '900.

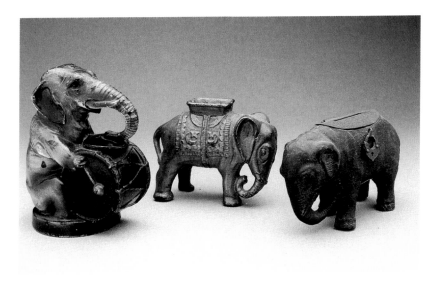

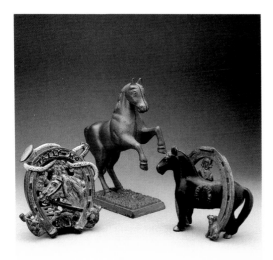

\mathcal{C}ast-iron still banks.
Tally Ho, England, Chamberlain & Hill.
A prancing horse on pebbled base, U.S.A.
A good luck horseshoe (Buster Brown & Tige),
U.S.A., Arcade, 1908–32.

Inghilterra e U.S.A., primi '900
Salvadanai statici in fusione di ferro.
Tally Ho della Chamberlain & Hill, Inghilterra.
Prancing Horse on pebbled base/U.S.A.
Good Luck Horseshoe (Buster Brown & Tige)
"Arcade", U.S.A. 1908–1932.

Cast-iron still banks by A.C. Williams
Company. A group of beautifully made lions. Opened
by unscrewing a cover on each lion's side.

U.S.A., 1905–34
Salvadanai statici/Fusione in ferro della A.C. Williams.
Gruppo di leoni di pregevole fattura.
Apertura: a vite sul fianco del leone.

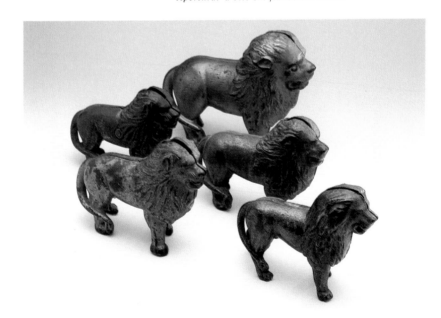

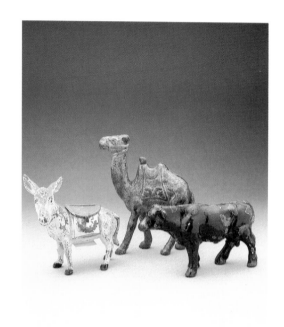

Still banks:
Donkey, Japan, lead.
Camel, U.S.A., Hubley/A.C. Williams Company,
U.S.A., 1920–1930s, cast iron.
Cow, U.S.A., Arcade, 1910–20, cast iron.

Giappone e U.S.A., primi '900
Gruppo di salvadanai statici.
Asino/Giappone/piombo.
Cammello/della Hubley; A.C.Williams U.S.A.
1920–30/Fusione di ferro.
Mucca/della Arcade U.S.A. 1910–20/Fusione di ferro.

England,
1 9 1 0 – 2 5

*B*anks by John Harper & Co. Ltd:
Cast-iron still banks. The golliwog, the hero of a
famous adventure story written in the late nineteenth
century. Opened by unscrewing a cover on the back.

Inghilterra, 1910–25
Salvadanai statici della John Harper & Co.
Ltd./Fusione in ferro.
"Golliwog" personaggio protagonista di un famoso
libro di avventure scritto alla fine del 1800.
Apertura: a vite sulla schiena.

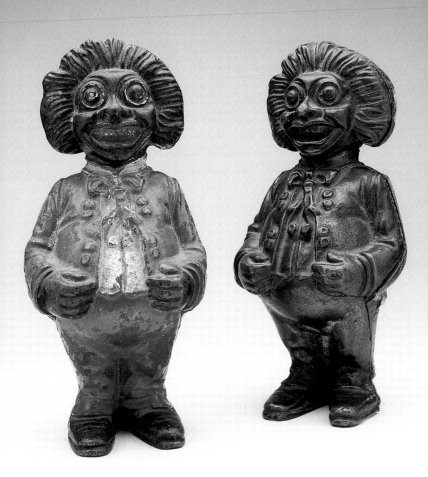

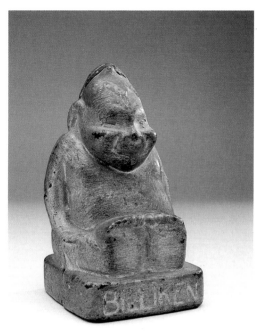

Cast-iron still banks
by A.C. Williams Company.
Billiken, a lucky-charm mascot
and symbol of things as they
ought to be. Opened by un-
screwing a cover on the back.

U.S.A., 1909–12
Salvadanaio statico della A.C.
Williams/Fusione in ferro.
"Billiken" personaggio porta
fortuna simbolo del come le
cose dovrebbero andare.
Apertura: a vite sulla schiena.
◄

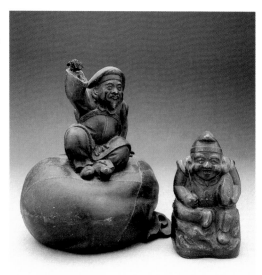

*L*ead still banks.
Daikoku (god of health).
Esibu (god of innocence).
Opened through a locked hinged door on the base.

Giappone, Pre Seconda Guerra Mondiale
Salvadanai statici/Piombo.
Daikoku (dio della salute).
Esibu (dio del candore).
Apertura: sportello con chiave sulla base.

*C*ast-iron character still banks.

Mutt & Jeff, A.C. Williams Company, 1912–31.
Characters from a comic strip that ran in the *San
Francisco Chronicle* in the early 1900s.

Boy Scout, A.C. Williams Company, 1910–34.
Produced on the occasion of the founding of the
first Boy Scout troops in the U.S.; retitled Soldier Boy
during World War I.

Foxy Grandpa, Wing and Hubley, 1920. Character
in a comic strip created by Charles Schulz and pub-
lished in the *New York Herald*.

Buster Brown & Tige, A.C. Williams Company,
1910–32. Characters from a very well-known comic
strip.

U.S.A., 1900–34
Salvadanai statici/Fusione in ferro.
Mutt & Jeff, della A.C. Williams U.S.A. 1912–31.
Personaggio di un fumetto dei primi del '900 della
rivista "San Francisco Chronicle".
Boy scout, della A.C. Williams U.S.A. 1910–34.
Salvadanaio realizzato alla fondazione dei primi grup-
pi dei boy scout negli U.S.A. e durante la Prima
Guerra Mondiale con il nome di "soldier boy".
Foxy Grampa, della Wing e Hubley U.S.A. 1920.
Personaggio di un fumetto creato da Carl Schulz e
pubblicato sul "N.Y. Herald".
Buster Brown & Tige della A.C. Williams U.S.A.
1910–32. Personaggio di un famosissimo fumetto.

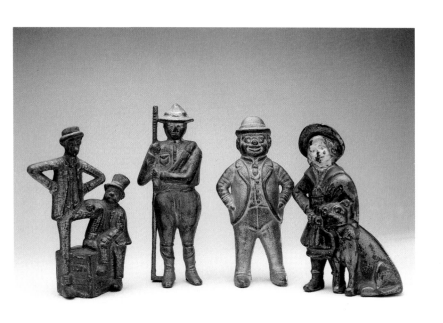

U.S.A.,
1930s

*H*ubley cast-iron still banks.
Dutch boy on a barrel.
Dutch girl holding flowers.
Opened by unscrewing a cover on the back.

U.S.A., anni 1930
Salvadanai statici della Hubley/Fusione in ferro.
Bimbo olandese sul barile.
Bimba olandese che tiene i fiori.
Apertura: a vite sulla schiena.

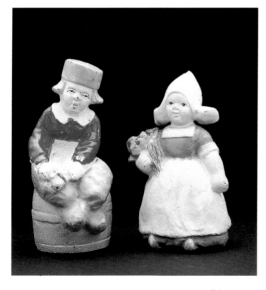

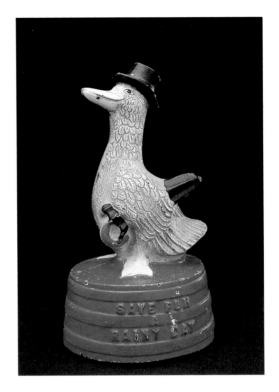

*H*ubley cast-iron still bank.
Barrel has the inscription, "Save for a rainy day."
Opened by unscrewing a cover on the barrel.

U.S.A., 1930–36
Salvadanaio statico della Hubley/Fusione in ferro.
Sul barile la scritta "risparmia per i tempi duri".
Apertura: a vite sul barile.

Italy,

Terra-cotta Santa Claus still bank, very fragile. Broken with the hands.

Italia, primi '900
Babbo Natale. Salvadanaio statico in terracotta, molto fragile. Veniva rotto con le mani.

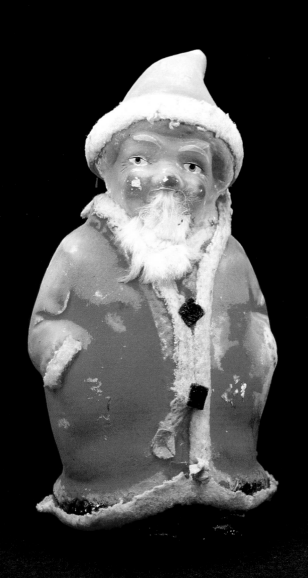

Still banks handed out to children by American banks during the holidays.

Sleeping Santa, Banthrico Inc., 1948, plaster. Opened by breaking.

Sleeping Santa, Banthrico Inc., 1950, metal alloy. Opened by unscrewing a cover underneath.

Santa with book. Opened by unscrewing a cover underneath.

U.S.A., 1948–50
Salvadanai statici distribuiti ai bimbi da banche U.S.A. durante le festività natalizie.
Babbo Natale che dorme, della Banthrico 1948/Gesso. Apertura: con rottura salvadanaio.
Babbo Natale che dorme, della Banthrico 1950/Lega. Apertura: a vite sottò la base.
Babbo Natale con libro. Apertura: a vite sotto la base.

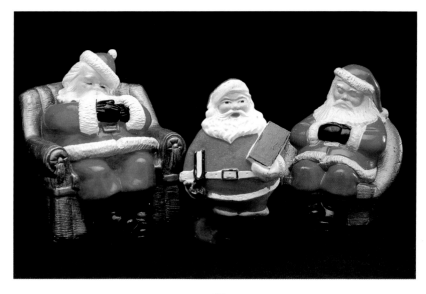

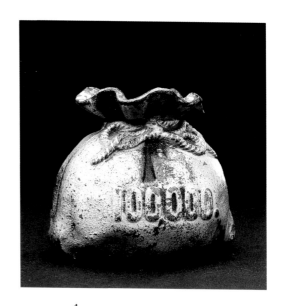

A cast-iron still bank shaped like a
$100,000 moneybag.

U.S.A., primi '900
Salvadanaio statico, Fusione in ferro.
A forma di sacco pieno di soldi (100.000$).

Germany,
CIRCA 1900

A still bank of silver-plated lead, shaped
like the transatlantic liner Europa. On the side is one
of Hamburg's major sights, the Rathaus. Opened
through a locked cover underneath.

Germania, 1900 circa
*Salvadanaio statico in piombo argentato a forma di
transatlantico "Europa" con simbolo sul fianco di un
monumento di Amburgo—Rathaus.
Apertura: sotto la base—sportello con chiave.*

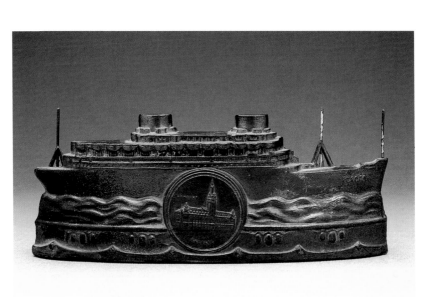

England and U.S.A.,

Cast-iron still banks:
A bear stealing honey. England, around 1908. Opened by unscrewing a cover on the back.

The Liberty Bell, commemorating U.S. independence, 1876. Opened underneath.

Inghilterra, fine '800–primi '900
Salvadanai statici/Fusione in ferro.
L'Orso che ruba il miele. Apertura: a vite su retro salvadanaio. Inghilterra 1908 circa.
La campana della libertà. Salvadanaio commemorativo della liberazione U.S.A./1876. Apertura: sotto la base.

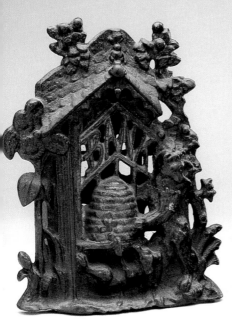
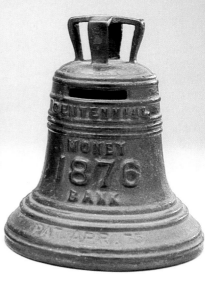

England,
1 9 5 3

*C*ast-iron still banks commemorating the
coronation of Queen Elizabeth II:
Coronation crown.
English throne, John Harper & Co. Ltd.
Another coronation crown.
All open underneath.

Inghilterra, 1953
*Salvadanai statici, fusione in ferro—commemorativi
dell'incoronazione di Elisabetta II.
Corona dell'incoronazione ai lati. Trono inglese/della
John Harper & Co. Ltd.
Apertura: sotto la base.*

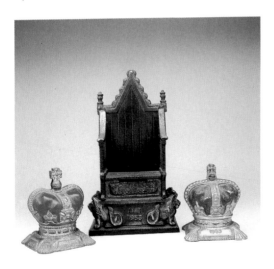

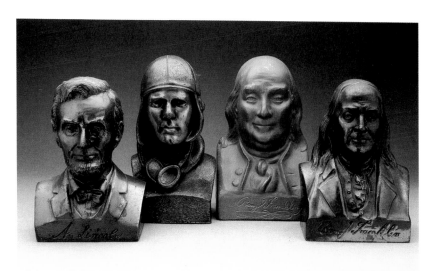

U.S.A.,
1 9 2 9 – 1 9 3 0s

*M*etal alloy still banks handed out by U.S. banks:
Abraham Lincoln. Charles Lindbergh, around 1929.
Benjamin Franklin, 1930s. Open through hinged doors underneath.

U.S.A., 1929–30
Salvadanai statici in lega distribuiti da banche U.S.A. Abramo Lincoln. Lindbergh 1929
circa. Benjamin Franklin 1930 circa.
Apertura: sportello sotto la base.

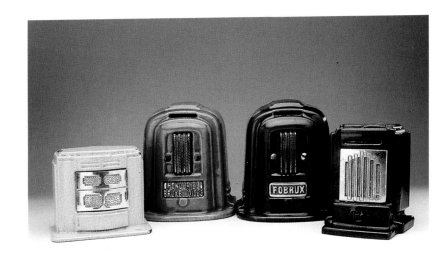

Northern Europe,
CIRCA 1960

Still banks shaped like heaters, cast iron.
Opened by unscrewing a cover.

Nord Europa, 1960 circa
Salvadanai statici a forma di stufa, Fusione in ferro.
Apertura: a vite.

U.S.A.,
1974

*M*etal alloy still banks by Banthrico Inc.

Model cars given out by commercial banks:

A 1927 Ford.

A 1955 Jaguar.

A 1935 taxi.

Opened through a cover on the underside.

U.S.A., 1974

Salvadanai statici in lega della Banthrico.

Riproduzioni di modelli d'auto distribuiti da banche.

Ford del 1927.

Jaguar del 1955.

Taxi del 1935.

Apertura: coperchio parte inferiore.

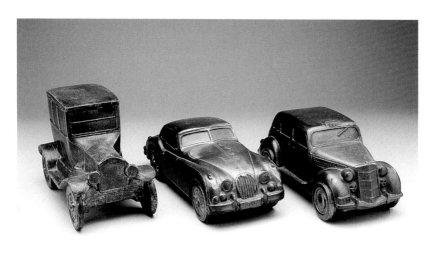

England,

A pair of still banks that helped perpetuate an infamous stereotype.

Cast iron and aluminum. Opened by unscrewing a cover on the back.

Inghilterra, fine '800–primi '900
Salvadanai statici a forma di negretto.
Esemplari in fusione in ferro e in alluminio.
Apertura: a vite sulla schiena.

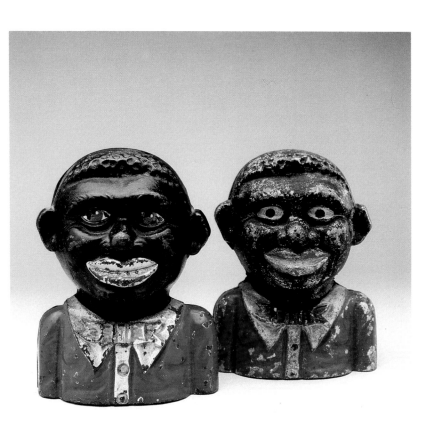

England,
1 8 8 0 T O 1 9 2 0 – 3 0

\mathcal{E}xamples of a now-
infamous series of mechanical
banks. Cast iron.

Short-sleeved Dinah, John
Harper & Co. Ltd., 1911–20.

Jolly Nigger Bank, John
Harper & Co. Ltd.

Jolly Nigger with round holes
on the head and back, eyes move
up and down.

Little J. Bank, John Harper & Co. Ltd., around 1910.

Jolly Nigger, aluminum, ears and eyes move, Starkie's, 1920.

Opened by unscrewing the base.

Inghilterra, 1880–1920–30
Salvadanai meccanici raffiguranti negretti/Fusione in ferro. "Dinah" con maniche corte
realizzato da John Harper & Co. Ltd. Inghilterra 1911-20.
"Jolly Nigger Bank." John Harper & Co. Ltd.
"Jolly Nigger", buchi tondi sulla testa e sulla schiena, muove gli occhi verso l'alto.
"Little J. Bank." John Harper & Co. Ltd. Inghilterra 1910 circa.
"Jolly Nigger" in alluminio; muove le orecchie e gli occhi. Starkie's—Inghilterra 1920.
Apertura: svitando la base.

England,

A cast-iron mechanical bank by John Harper & Co. Ltd.
The back reads "Jolly Nigger Bank, Pat. Mar.14.82." Opened by unscrewing the base.

Inghilterra, fine '800–primi '900
Salvadanaio meccanico della John Harper & Co. Ltd./Fusione in ferro.
Nella parte posteriore appare la scritta "Jolly Nigger Bank". Pat. Mar.14.82.
Apertura: svitando la base.

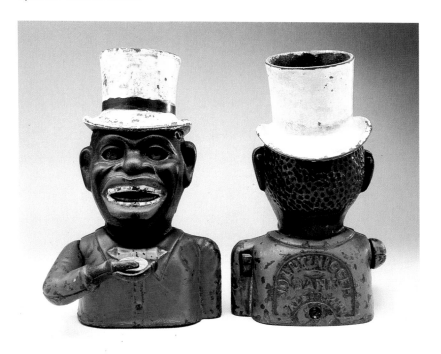

U.S.A.,
1 8 8 6

A cast-iron mechanical bank by Shepard Hardware Co., Pat. 11.16.1886.

The coin is placed in the hand. When you press the button on the base, the orator lowers his arm and puts the coin in his bag. Opened through locking hinged door on the rear of the base.

U.S.A., 1886
Salvadanaio meccanico della Shepard Hardware Co.
Pat. 16.11.1886/Fusione di ferro.
Mettendo la monetina sulla mano e premendo il pulsante sulla base, l'omino abbassa il braccio introducendo la moneta nella borsa.
Sportello con serratura sulla parte posteriore della base.

Cast-iron Uncle Sam mechanical bank by
Shepard Hardware Co., Pat. 8.6.1886.

The coin is placed in the hand. When you press the
button on the base, Uncle Sam lowers his arm and
puts the coin in the bag. Opened through a locking
hinged door on the rear of the base.

U.S.A., 1886
Il salvadanaio dello zio Sam della Shepard Hardware
Co. Pat. 6.8.1886/Fusione di ferro.
Mettendo la moneta sulla mano dell'oratore e premen-
do il pulsante sulla base, l'omino abbassa il braccio
introducendo la moneta nella borsa.
Apertura: a sportello con serratura retro della base.

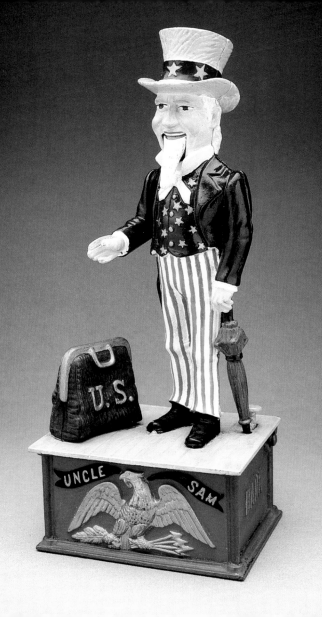

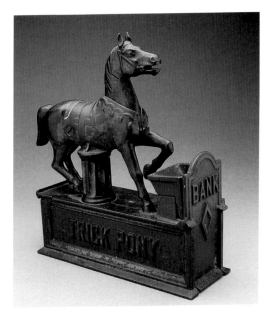

Cast-iron Trick
Pony mechanical bank by
Shepard Hardware Co., Pat.
2.6.1885.

The coin is placed in the
pony's mouth. When you pull
the lever, the pony lowers its
head and puts the coin in the
manger. Opened by removing
a plug from the base.

U.S.A., 1885
*Salvadanaio meccanico della
Shepard Hardware Co. Pat.
6.2.1885/Fusione in ferro.
Trick Pony. Mettendo la mon-
eta sulla bocca del cavallino e
tirando la leva il pony abbassa
la testa e pone i soldi nella
mangiatoia.
Apertura: tappo alla base.*
◄

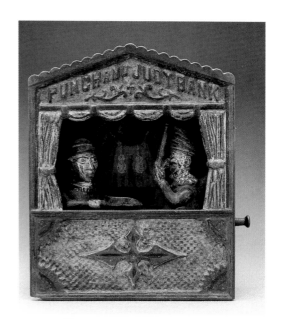

C ast-iron mechanical banks by Shepard
Hardware Co., Pat 2.6.1885.

When the lever on the side is pulled, Judy takes the
coin on the tray. When Punch swings his rolling pin,
Judy turns and drops the coin into the moneybox.
Opened by unscrewing the base.

U.S.A., 1885
Salvadanaio meccanico della Shepard Hardware Co.
Pat. 6.2.1885/Fusione in ferro.
Tirando la leva laterale Judy riceve la moneta sul vas-
soio, Punch picchia con il mattarello e Judy si gira e
depone la moneta nel salvadanaio.
Apertura: svitando la base.

U.S.A.,

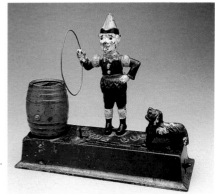

*C*ast-iron mechanical bank (base cast in a single piece) by Hubley Manufacturing Co. When you put the coin in the dog's mouth and pull the lever, the dog jumps through the hoop and deposits the money in the barrel. Opened by unscrewing a cover in the base.

U.S.A., 1925–36
Salvadanaio meccanico della Hubley
Manufacturing Co./Fusione in ferro (base in un pezzo unico). Mettendo la moneta
nella bocca del cane e tirando la leva, lo stesso salta nel cerchio e deposita la moneta
nella botte. Apertura: portellino da svitare sotto la base.

U.S.A.,

1 8 8 8

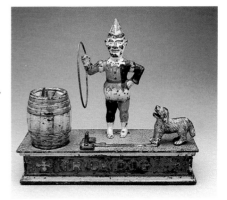

*C*ast-iron mechanical bank. Shepard Hardware Co., U.S. Pat. July 31, 1888. Works like the one above.

U.S.A., 1888
Salvadanaio meccanico della Shepard
Hardware Co. Pat. 31 luglio,
1888/Fusione in ferro. Movimento:
uguale al modello sopra descritto.

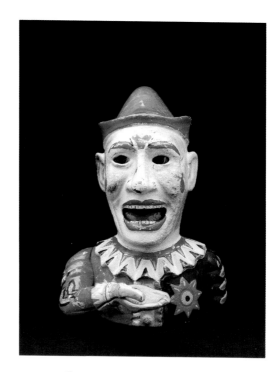

C ast-iron mechanical Humpty Dumpty bank
by Shepard Hardware Co., Pat. 6.17.1884.

When the lever on the back is pressed, the clown
raises his hand and swallows the coin. Opened by
unscrewing the base.

U.S.A., 1884
Salvadanaio meccanico Humpty Dumpty della Shepard
Hardware Co. Pat. 17.6.1884 /Fusione in ferro.
Premendo la leva posta sulla schiena, il pagliaccio
solleva la mano e mangia la moneta.
Apertura: si svita la base.

U.S.A.,
1 9 3 0

*C*ast-iron mechanical bank by Hubley
Manufacturing Co.

A coin is inserted in the elephant's trunk. When its
tail is pulled, the elephant deposits the coin in the
howdah. Opened by unscrewing a cover on the side.

U.S.A., 1930
*Salvadanaio meccanico della Hubley Manufacturing
Co./Fusione in ferro.*
*Ponendo la moneta sulla proboscide e tirando la coda,
l'elefante la ripone all'interno della portantina.*
Apertura: a vite sul fianco. ➤

U.S.A.,
CIRCA 1906 – 26

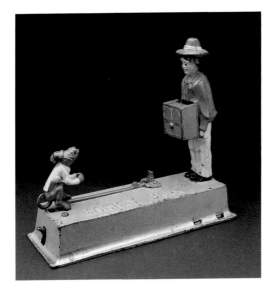

*C*ast-iron mechanical
bank by Hubley Manufacturing
Co. When the lever is pressed,
the monkey jumps up and
deposits the coin in the barrel
organ.

U.S.A., 1906–26 circa
*Salvadanaio meccanico della
Hubley Manufacturing
Co./Fusione in ferro.*
*Premendo la levetta la scimmi-
etta salta e pone la moneta
all'interno dell'organetto.*
◄

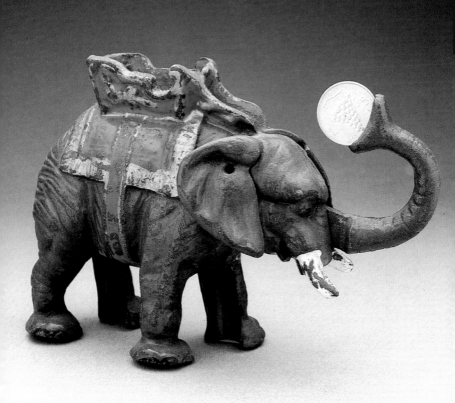

U.S.A.,
1 8 8 2

\mathcal{C}ast-iron mechanical bank by Kyser and Rex Co., U.S. Pat. 6.13.1882. A coin is placed in the monkey's hand. When the handle is turned, the barrel organ plays, the cat and dog pirouette, and the monkey raises his hat in thanks while depositing the coin into the bank. Opened through a hinged door in the base.

U.S.A., 1882
Salvadanaio meccanico della Kyser e Rex Co. Pat. 13.6.1882/Fusione in ferro.
Si mette il soldo sul piatto e girando la manovella l'organetto suona, la scimmietta alza il cappellino ringrazia e pone la moneta nel salvadanaio. Il cane e il gatto girano su se stessi ballando. Apertura: sportellino sotto la base.

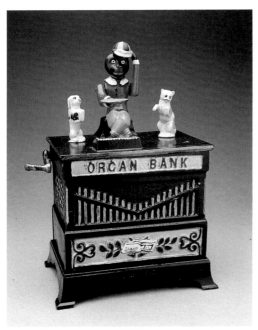

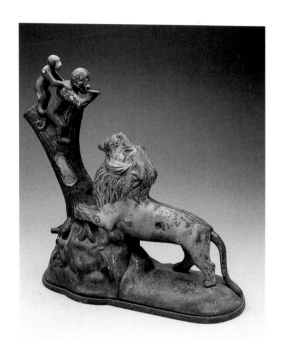

*M*echanical bank by Kyser and Rex Co.,
U.S. Pat. 7.17.1883.

A coin is placed in the monkey's hand. When the
lever on the base is turned, the lion opens his mouth
and the monkey drops the coin in. Opened through a
hinged door in the base.

U.S.A., 1883

Salvadanaio meccanico della Kyser e Rex Co. Pat.
17.7.1883.
Mettendo la moneta in mano alla scimmietta, e giran-
do la levetta sulla base, il leone apre la bocca e la
scimmia vi depone la moneta.
Apertura: sportello sotto la base.

U.S.A.,

1 8 6 9

\mathcal{H}all's Excelsior Bank, designed by John D. Hall, the J. & E. Stevens Co., U.S. Pat. 12.21.1869.

A cast-iron mechanical bank. When the doorknob is pulled, a little pig dressed like a banker pops out of the top and takes the coin. Opened by screws that attach the roof to the base.

U.S.A., 1869
Salvadanaio meccanico della J.& E. Stevens Co. Pat. 21.12.1869. Disegnato da John D. Hall/Fusione in ferro.
Tirando il pomo sulla porta fuoriesce un maialino banchiere che raccoglie la monetina.
Apertura: vite sul tetto che tiene unita la base.

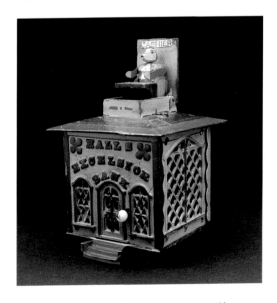

*T*ammany Bank, designed by J.D. Hall, the
J. & E. Stevens Co., U.S. Pat. 12.23.1873.

Mechanical banks. When a coin is placed in the
man's hand, he automatically deposits it into his
jacket pocket. Opened through a sliding door. Screw-
secured.

U.S.A., 1873
Salvadanai meccanici della Tammany Bank disegnato
da J. D. Hall per la J. & E. Stevens Co. Pat.
23.12.1873.
Mettendo la moneta in mano all'omino, egli la
depone automaticamente nella tasca della giacca.
Apertura: sportellino scorrevole chiuso a vite.

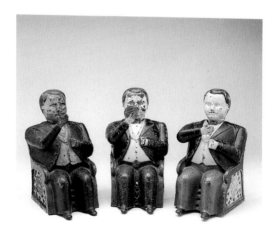

U.S.A.,
1 8 7 6

\mathcal{D}esigned by Henry W. Prouty, the J. & E. Stevens Co., U.S. Pat. 3.7.1876. A cast-iron mechanical bank. When the door is opened, the banker in the back greets the saver. When a coin is placed on the support and the lever beside the door is pressed the coin goes into the bank. Opened through a screw-secured sliding door underneath.

U.S.A., 1876

Salvadanaio meccanico disegnato da Henry W. Prouty per la J. & E. Stevens Co. Pat. 7.3.1876. Fusione in ferro.
Aprendo la porta si affaccia sul retro il banchiere e ponendo la moneta sul supporto, e premendo la levetta laterale alla porta, essa viene riposta nel salvadanaio.
Apertura: sportellino scorrevole a vite sotto la base.

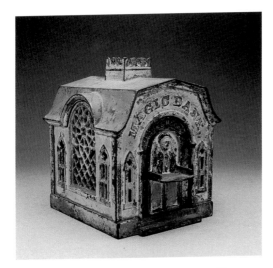

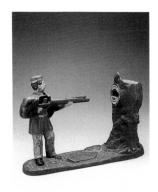

U.S.A.,
1 8 8 7

\mathcal{D}esigned by James H. Bowen, the J. & E. Stevens Co., U.S. Pat. 1.6.1887.

A cast-iron mechanical bank. "Creedmoor Bank Pat. Nov. 3, 1887" is written on the base of the tree trunk. Opened by removing an iron plug underneath.

U.S.A., 1887
Salvadanaio meccanico disengato da James H. Bowen per la J. & E. Stevens Co./Fusione in ferro.
Sulla base del tronco tagliato c'è scritto Creedmoor Bank Pat. Nov.3.1887.
Apertura: tappo in ferro sotto la base.

U.S.A.,
1 8 8 6

\mathcal{D}esigned by Russel Frisbie, the J. & E. Stevens Co., U.S. Pat. 6.23.1886.

A cast-iron mechanical bank. When a coin is placed on the crossbow and William Tell's foot is pressed, he shoots the coin into the apple on the boy's head. Opened by removing a plug underneath.

U.S.A., 1886
Salvadanaio meccanico disegnato da Russel Frisbie della J. & E. Stevens Co., Pat. 23.6.1886. Fusione in ferro.

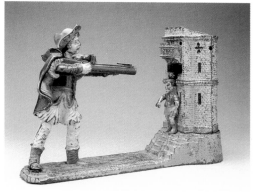

Mettendo la moneta sulla balestra e schiacciando il piede di Guglielmo Tell colpisce la mela posta sulla testa del bimbo. Apertura: tappo sotto la base.

\mathcal{D}esigned by J.H. Bowen, the J. & E.
Stevens Co., U.S. Pat. 4.27.1880.

A cast-iron mechanical bank. When a coin is placed
on the bulldog's nose and his tail is pulled, he opens
his mouth and swallows the money. Opened by
removing a plug underneath.

U.S.A., 1880
Salvadanaio meccanico disegnato, J.H. Bowen per la
J. & E. Stevens Co. Pat. 27.4.1880. Fusione in ferro.
Mettendo la moneta sul naso del bulldog e tirando la
coda, il cane apre la bocca e la inghiotte.
Apertura: a tappo sotto la base. ➤

Bull Dog Bank
Detail of the base.

Salvadanaio Bulldog
Particolare base.

◄

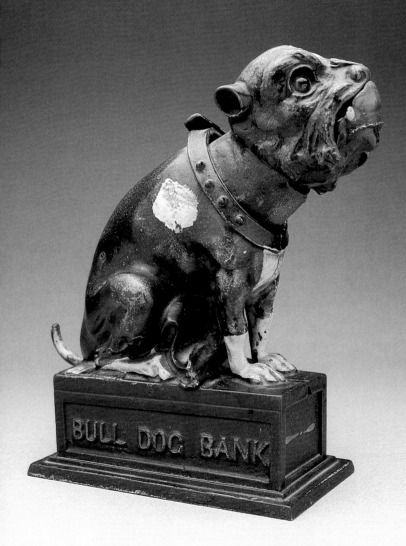

U.S.A.,

LATE 19ᵀᴴ–EARLY 20ᵀᴴ CENTURY

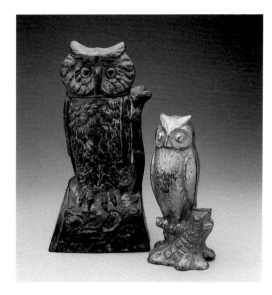

 \mathcal{C} ast-iron banks:

An owl mechanical bank that turns its head, the J. & E. Stevens Co., U.S. Pat. 9.28.1880. When a coin is placed on the branch and the lever on the back is pushed, the owl turns its head and pushes the coin inside.

A "Be wise" owl still bank, A.C. Williams Company, U.S.A., 1912–20s. Opens by removing a plug underneath or by unscrewing a cover on the back.

U.S.A., fine '800–primi '900

Salvadanai/Fusione in ferro.

Meccanico (Owl, turns head) della J. & E. Stevens Co. Pat. 28.9.1880.

Mettendo una moneta sul ramo e premendo la leva posteriore il gufo gira la testa e la spinge all'interno.

Statico (Be wise owl) della A.C. Williams/1912–20.

Apertura: tappo sotto la base e a vite nella parte posteriore.

\mathcal{D}esigned by Charles H. Menn, the J. & E. Stevens Co., U.S. Pat. 1.23.1883.

Cast-iron mechanical bank. When a coin is placed in the eagle's beak and the lever is pushed down, the eagle feeds the coin to the eaglets and into the bank. Opened by removing a plug underneath.

U.S.A., 1883
Salvadanaio meccanico disegnato da Charles H. Menn per la J. & E. Stevens Co. Pat. 23.1.1883. Fusione in ferro.
Mettendo una moneta nel becco dell'aquila e abbassando la leva, viene portata verso gli aquilotti e depositata nel salvadanaio.
Apertura: tappo metallo sotto la base.

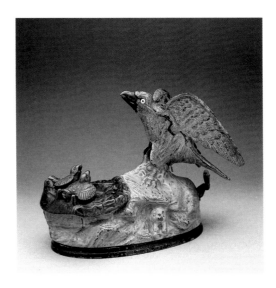

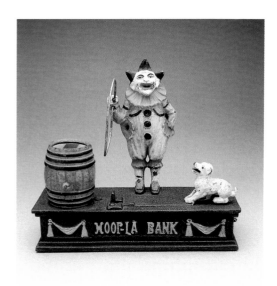

*J*ohn Harper & Co. Ltd., England,
Reg. 1.7.1897.

A cast-iron mechanical bank. When a coin is placed
in the dog's mouth and the lever is pulled, the dog
jumps through the hoop and deposits the coin in the
barrel. Opened by removing a plug underneath.

Inghilterra, 1897
Salvadanaio meccanico della John Harper & Co. Ltd.
Pat. 7.1.1897/Fusione in ferro.
Mettendo la moneta nella bocca del cane, e tirando la
leva, lo stesso salta nel cerchio e deposita la moneta
nella botte.
Apertura: tappo sotto la base.

Germany,
1928

A tinplate mechanical bank by Selhumer & Strauss. When a lever on the front is pressed, the tongue emerges, swallowing the coin into the bank. Opened through a locking hinged door underneath.

Germania, 1928
Salvadanio meccanico della Selhumer & Strauss/Latta. Premendo la levetta sul frontale esce la lingua che preleva la moneta e la inghiotte nel salvadanaio. Apertura: sportellino a chiave sotto la base.

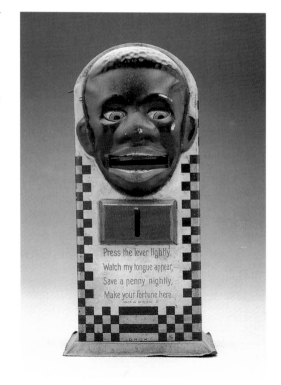

Press the lever lightly,
Watch my tongue appear,
Save a penny nightly,
Make your fortune here.
MADE IN GERMANY

U.S.A.,
1 8 8 8 – 9 0

A cast-iron mechanical cash register for dimes. The counter records the coins and displays the total contained inside. Opens automatically when a preset total is reached.

U.S.A., 1888–90
Salvadanaio meccanico/Fusione in ferro.
Registratore di monete da 10 centesimi. Il contatore le registra visualizzandone il valore contenuto.
Apertura: automatica a raggiungimento cifra prestabilita.

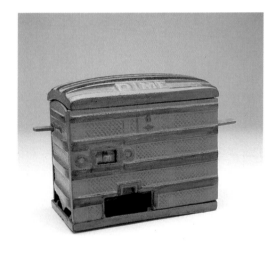

U.S.A.,

*V*arious models of cash-register banks by the Durable Toy and Novelty Co.

U.S.A., 1912 circa
Modelli diversi di salvadanai registratore di cassa della Durable Toy and Novelty Co. ➤

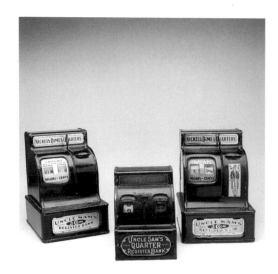

U.S.A.,

1929

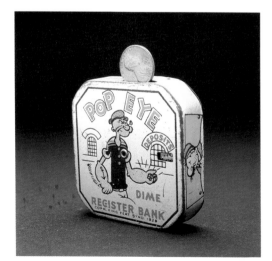

A tinplate coin register bank, copyright King Features Syndicate. The window displays the total amount deposited. Opens automatically when a five-dollar total has been reached.

U.S.A., 1929
Salvadanaio registratore di monetine copyright della King Feat Synd/Latta. Nella finestrina viene visualizzato l'ammontare dei depositi effettuati. Apertura: a raggiungimento cifra prestabilita $5.
◄

France and U.S.A,

LATE 19ᵀᴴ CENTURY

*C*ast-iron and brass still banks. French
caisse, late nineteenth century, brass, depicting a
mouse climbing the 16 stairs. Roff Bank, U.S.A., J. &
E. Stevens Co., 1887. Opened by unscrewing the half-
moon on the roof and taking the bank apart.

Francia e U.S.A, fine '800
Salvadanai statici./Fusione in ferro e ottone.
"Cassa"/Francia, in ottone.
Particolare del topolino che sale la scala di 16 scalini.
Roff "Bank" della J. & E. Stevens Co./U.S.A. 1887.
Apertura: svitando la mezzaluna sul tetto si smonta
la cassa.

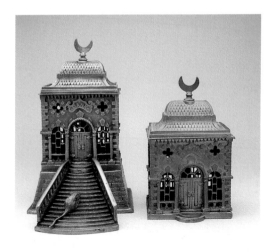

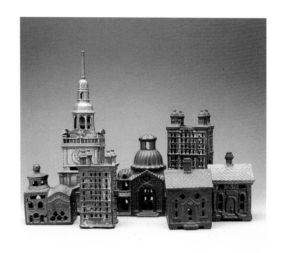

*C*ast-iron still banks:
Mosque, early 1900s.
Independence Hall tower, Enterprise Mfg. Co., 1876.
Skyscraper, A.C. Williams Company, 1900–31.
Domed mosque, Gray Iron Casting Co., 1903–28.
One-story house, J. & E. Stevens Co., 1883.
Opened by unscrewing a cover on the bottom or back.

U.S.A., fine '800–primi '900
Salvadanai statici./Fusione in ferro.
Mosque/primi '900
Independence Hall tower della Enterprise Mfg. Co.,
1876.
Skyscraper della A.C. Williams, 1900–31.
Domed mosque bank della Gray Iron Casting Co.,
1903–28.
One story house della J. & E. Stevens Co., 1883.
Apertura: a vite sul retro o sotto la base.

Europe,

**LATE 19TH
CENTURY**

Very large still banks of aluminum and cast iron.

Coins are inserted in a slot at the back. The tip of the tower acts as a locking pin that allows all sides of the building to be taken apart.

Europa, fine '800
Esemplari molto grandi di sal-
vadanai statici/Alluminio e
fusione di ferro.
Inserimento delle monete nella
fessura posta posteriormente al salvadanaio. Apertura: il puntale della torre fa da perno
che permette di smontare tutte le facce della casa.

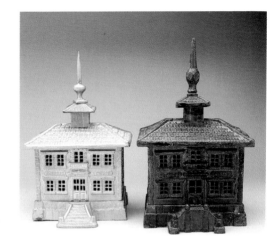

France,

LATE 19TH CENTURY

Group of French cast-iron and brass *caisses*. Still banks with various distinguishing details (flags, animals, and figurines). Opened by unscrewing a cover on the back or underneath.

Francia, fine '800
Gruppo di "casse"/Fusione in
ferro/ottone. Salvadanai statici
con diversi particolari che
caratterizzano la cassa
(bandiere, animaletti e omini).
Apertura: a vite sul retro o
sotto la base.

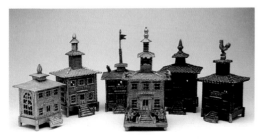

France,

*C*ombination-lock tinplate miniature safes. (See next page.)

Francia, primi '900
Salvadanai a combinazione Latta. Casseforti. (Vedi pagina successiva.) ➤

Hungary,
LATE 19ᵀᴴ CENTURY

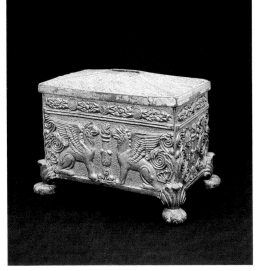

A still bank designed as a casket with griffins. Opened through the lid of the casket.

Ungheria, fine '800
Salvadanaio statico. Scrigno con leoni alati.
Apertura: coperchio dello scrigno.
➤

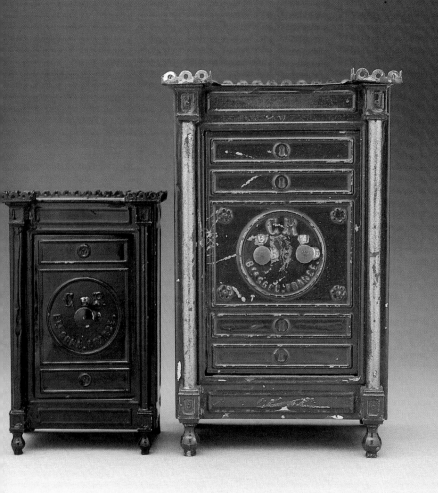

England and Europe,

*T*inplate banks:
The Daily Mail saving bank, England, around 1900. A coin register that opens automatically when a preset total has been reached.

Easter egg, Europe, late 19th–early 20th century. A hinged cover underneath is opened with a key.

Vrye Universiteit, Holland, 1937. A bank commemorating October 23, 1837–1937. Opened by removing the padlock on the lid.

Inghilterra e Europa, fine '800–primi '900
Salvadanai./Latta.
The "Daily Mail" Saving Bank, Inghilterra circa 1900. Registratore di cassa. Apertura: automatica a cifra prestabilita.
Uovo Pasqua/Europa fine '800–primi '900. Sportello a chiave sotto la base.
Vrye Universiteit/Olanda 1937. Commemorativo (23 Oct. 1837–1937).
Lucchetto sul coperchio.

U.S.A.,
LATE 19TH CENTURY

Cast-iron miniature safe still banks.

Safe, J. & E. Stevens Co., 1891. Open through a hinged door with lock.

Coin deposit bank with a numerical combination.

U.S.A., fine '800
Salvadanai statici.
Casseforti./Fusione di ferro.
"Safe" della J. & E. Stevens Co./U.S.A. 1891. Sportello con serratura.
"Coin deposit bank".
Combinazione numerica.

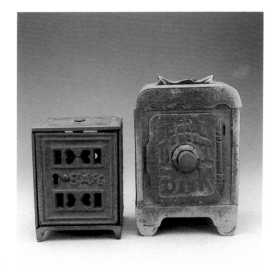

Europe and U.S.A.,
VARIOUS PERIODS

These miniature combination safes of various materials of tinplate, iron, and metal alloy can be opened with a combination or a key.

Europa e U.S.A., varie epoche
Salvadanai a combinazione realizzati in diversi materiali (latta, ferro, lega) e in nazioni diverse (U.S.A./Europa). Apertura: a combinazione e a sportello a chiave.

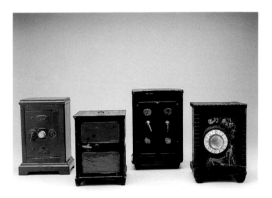

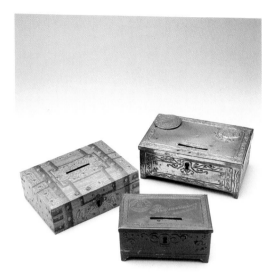

Italy,

Distributed by Il Risparmio bank. These decorative tinplated still banks have lids that can be opened with a key.

Italia, fine '800–primi '900
Salvadanai statici/Cassette "Il Risparmio"/Latta.
Apertura: del coperchio con serratura a chiave.
≺

Italy,

CIRCA 1930–40

Banca Agricola Italiana gave away leather-covered brass still banks like these to encourage people to open savings accounts. The cover of the book opens with a key, but the saver had to go to the bank to unlock it, as the key was kept at the bank. (See next page.)

Italia, 1930–40 circa
Salvadanaio statico ottone rivestito in pelle—distribuito dalla Banca Agricola Italiana per incentivare l'Apertura: di libretti di risparmio.
Apertura: a chiave della copertina del libro, la chiave veniva consegnata alla banca. (Vedi pagina successiva.) ➤

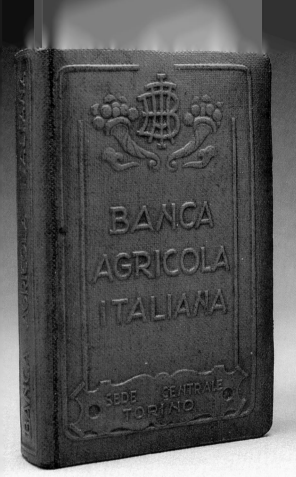

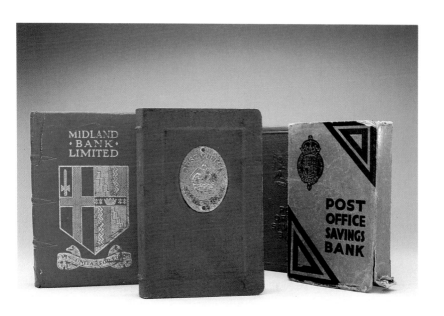

England,
EARLY 20TH CENTURY

*B*ankbooks, brass and leather. Like those immediately preceding, these still banks were handed out by banks and post offices to encourage savings accounts. Again, the keys to the books were consigned to the bank; when a box was full, the owner would go to the bank to deposit the money into savings.

Inghilterra, primi '900
Libretti risparmio/Ottone e pelle.
Salvadanai statici. Distribuiti dalle banche e dagli uffici postali per conti di risparmio.
Come per quelli precedenti la chiave veniva consegnata alla banca e quando la scatola era piena, il proprietario doveva andare alla banca per depositare il denaro.

England,
CIRCA 1918

This bullet-shaped still bank commemorates World War I; closed with a plug underneath.

Inghilterra, 1918 circa
*Salvadanaio statico commemo-rativo/Prima Guerra Mondiale 1914–18.
Apertura: tappo sotto la base.*

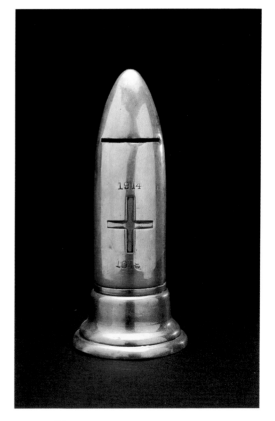

Italy,

EARLY 20ᵗʰ CENTURY

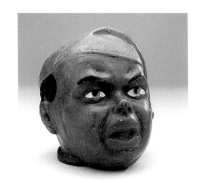

This terra-cotta still bank depicts a native during the time of the Abyssinian war. It may only be opened by breaking. ➤

Italia, primi '900 Salvadanaio statico/ Terracotta, raffigurante negretto della guerra di Abissinia. Apertura: rottura salvadanaio.

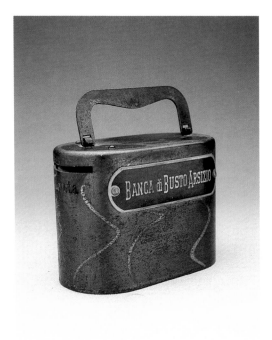

Italy,

CIRCA 1930 – 40

Distributed as propaganda among the "Balilla" (members of the Fascist youth organization) this cast-iron still bank from the Banca di Busto Arsizio was ostensibly used to promote savings "for the prosperity and development of the nation." The key was retained by the bank.

Italia, circa 1930–1940 Salvadanaio statico-Fusione ferro, della banca di Busto Arsizio. Per promuovere il risparmio per "il benessere e lo sviluppo della patria". Era distribuito e propagandato tra piccoli "balilla". La chiave era conservata dalla banca.

Italy,
1 9 3 2

*T*his Italian postcard urges, "Balilla, learn to save: You will lay the foundations of prosperity for yourself and the nation."

It was designed by Bianchi and handed out by the Cassa di Risparmio delle Province Lombarde, a savings institution.

Italia, 1932
Cartolina italiana che dice: "Balilla, abituati al risparmio: preparerai il benessere tuo e quello della patria". Disegnata da Bianchi era distribuita dalla Cassa di Risparmio delle Province Lombarde.

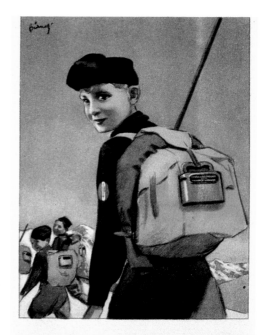

"Balilla, abituati al risparmio: preparerai il benessere tuo e quello della Patria"

Italy,
1930-50

\mathcal{T}hese cast-iron still banks from various Italian banking institutions may be opened from underneath with a key.

Italia, 1930–50
Salvadanai statici di diverse banche italiane. Fusione ferro.
Apertura: a chiave sotto la base.

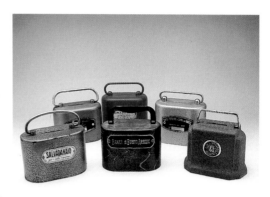

Italy,
CIRCA 1930-50

\mathcal{T}he league of Italian Banks commissioned these still banks to promote savings accounts. They may be opened with a key underneath.

Italia, 1930–50 circa
Salvadanai statici. Lega delle banche italiane per promuovere l'Apertura: di libretti di risparmio.
Apertura: sportello a chiave sotto la base.

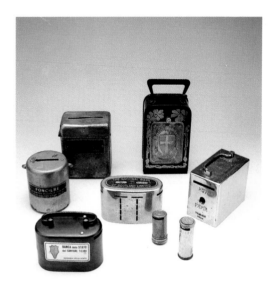

𝒯hese still banks of cast iron and tinplate
come from Hungary, Switzerland, England, Austria,
and Czechoslovakia.

One is imprinted "Learn to save young so you're
not hungry when you're old." Opened with a door or
by unscrewing a cover underneath.

Europa, primi '900
Salvadanai statici di diverse nazioni./Fusione in ferro
e latta Provengono da: Ungheria, Svizzera,
Inghilterra, Austria, Cecoslovacchia
Su uno è stampata una frase: "Imparate a risparmiare
da giovani per non avere la fame da vecchi".
Apertura: sportello o a vite sotto la base.

A tinplate bank handed out for World Savings Day. It opens up into two parts at the equator. (See next page.)

Italia, 1950 circa
Salvadanaio/Latta.Distribuito per la giornata mondiale del risparmio.
Apertura: in due strati (equatore). (Vedi pagina successiva.) ➤

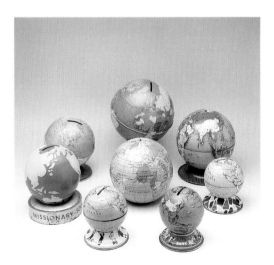

L ithographed tinplate still banks made for World Savings Day, missions, and various charities. Plug or hinged door underneath.

Italia, 1950 circa
Salvadanai statici/ Lattalitografata. Realizzati per la giornata mondiale del risparmio, per le missioni e vari enti benefici. Tappo o sportellino sotto la base.
◄

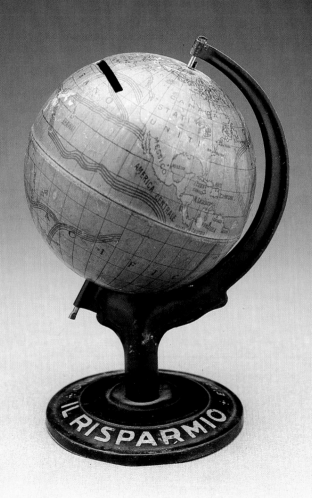

Switzerland,
1990

*F*oscarino the owl, a still bank of wood from the Union of Swiss Banks, encouraged children to save. Opens by a hinged door underneath.

Svizzera, 1990
Foscarino—Salvadanaio statico della UBS (Unione Banche Svizzere)/Legno. Realizzato per i conti di risparmio della gioventù. Apertura: sportello sotto la base.
≺

Switzerland,
1990 – 91

*M*odels from Swiss banks. Open by a hinged door underneath.

Svizzera, 1990–91
Salvadanai delle banche svizzere. Apertura: sportello sotto la base. ≻

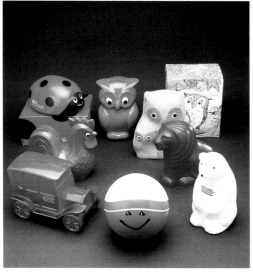

Italy,

*I*ron still banks:
"Save a coin a day to ensure a
happier tomorrow."

Italia, 1940–50 circa
Salvadanai statici/Ferro.
"Risparmia una moneta al di'
per assicurarti un domani più
felice".

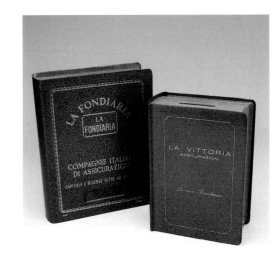

Italy,

*M*echanical clock banks of wood and metal alloy. Inserting a coin starts the clock mechanism, which runs until the next day. Open by a hinged door underneath.

Italia, primi '900
Esemplari di orologi
Salvadanai meccanici/Legno e
lega. Inserendo una monetina
si avvia il meccanismo
dell'orologio che per un altro
giorno funziona. Apertura:
sportello sotto la base.

Italy,

EARLY 20ᵀᴴ
CENTURY

*I*ron insurance-company clock banks. Open by a hinged door underneath.

Italia, primi '900
Originali esemplari di orologi
salvadanai di Compagnie di
Assicurazione./Ferro.
Apertura: sportello sotto la
base.

Germany,
CIRCA 1950

Still bank. A lithographed box, probably used for candy, depicting the head office of a large bank. The lid can be opened with a key.

Germania, 1950 circa

Salvadanaio statico, scatola litografata (usata probabilmente per contenere dolci). Raffigura la sede di una grande banca. Apertura: coperchio con serratura.

North Europe,
1 9 3 0 – 4 0

*L*ithographed tinplate still bank in the shape of a Parein cookie tin. The roof can be opened with a key.

Nord Europa, 1930–40 circa
Salvadanaio statico/Latta litografata.
Scatola di biscotti Parein.
Apertura: dal tetto con serratura.

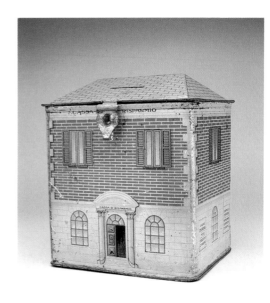

Savings Bank, from the Il Risparmio bank in the town of Imperia.

Still bank, candy box (Schiarino). The roof opens and can be fitted with a padlock.

Italia, 1930–50
Salvadanaio statico/Cassa di Risparmio di Imperia.
Scatola di caramelle (Schiarino). Apertura: dal tetto
con lucchetto.

*L*ithographed tinplate banks:

Vending machine (G. Stollwerck, Hand Shadows). Insert a coin and pull the lever, and a product comes out (French version with "shadow theater"). Locked on the side.

Cookie tin, H.B. & S., Ltd., Reading, England, early 20th century. Illustrated are gnomes carrying pennies into the bank. The lid of the box opens. (See next page.)

Europa, fine '800–primi '900
Salvadanai/Latta litografata.
"Venditore automatico" (G. Stollwerck—hand shadows). Inserendo la moneta e tirando la leva si poteva ritirare un prodotto (versione francese con ombre cinesi). Serratura laterale.
Scatola biscotti della H.B. & S. Ltd. Reading./Inghilterra primi '900. Sono raffigurati degli gnomi che trasportano dei penny all'interno della scatola salvadanaio. Apertura: coperchio scatola (vedi pagina successiva). ➤

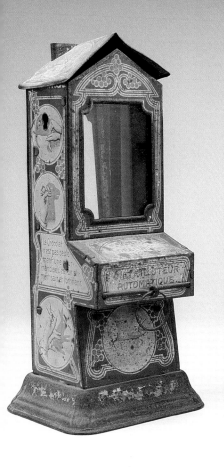
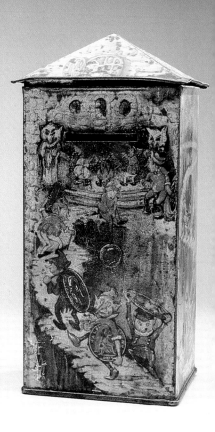

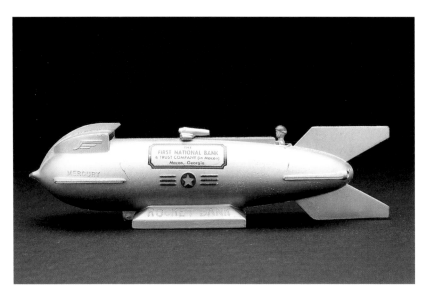

U.S.A.,

CIRCA 1950

*M*ercury, a rocket mechanical bank of metal alloy. Put the coin on top of the bank, and press the pilot's head. This triggers the little sliding airplane, which pushes the coin into the slot at the front of the main craft.

Inspired by the adventures of comic-book characters in the 1950s. The door underneath is opened with a key.

U.S.A., 1950 circa
Salvadanaio "Mercury" meccanico spaziale in lega.
Mettendo la moneta sopra il salvadanaio, e premendo la testa del pilota del razzo, scatta l'aereo cursore che la spinge nella fessura della parte anteriore della navicella.
Si ispira alle fantastiche avventure dei personaggi dei fumetti anni '50.
La porta sul fondo si apre con una chiave.

U.S.A.,

*M*etal alloy mechanical bank by Duro Mold and Mfg. Inc.
Press the button on the base and the airplane pushes the coin into
the planet. Locking plug in the planet.

U.S.A., 1950–60 circa
Salvadanaio meccanico/Lega. Della Duro Mold and M.F.G. Inc.
Premendo il pulsante sulla base l'aereo invia la moneta all'interno
del pianeta. Tappo a serratura sul pianeta.

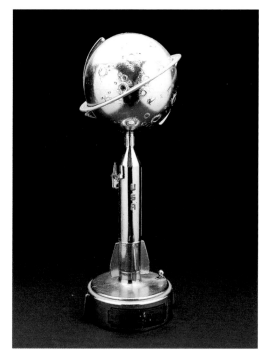

U.S.A.,
CIRCA 1950-60

A valuable group of metal alloy mechanical space banks, distributed by banking institutions. (See next page.)

U.S.A., 1950-60 circa
Salvadanai spaziali. Pregevole serie di salvadanai meccanici in lega. Distribuiti dalle banche. (Vedi pagina successiva.) ➤

U.S.A.,
CIRCA 1950

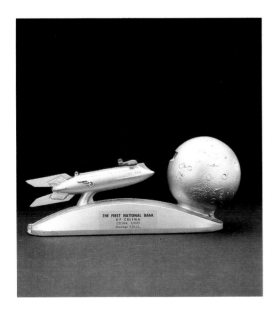

THE FIRST NATIONAL BANK
OF CELINA
CELINA, OHIO
Member F.D.I.C.

*M*etal alloy mechanical bank distributed by American banking institutions. A hinged door underneath opens with a key.

U.S.A., 1950 circa
Salvadanaio meccanico/Lega. Distribuito da banche U.S.A. Sportello con chiave sotto la base.
➤

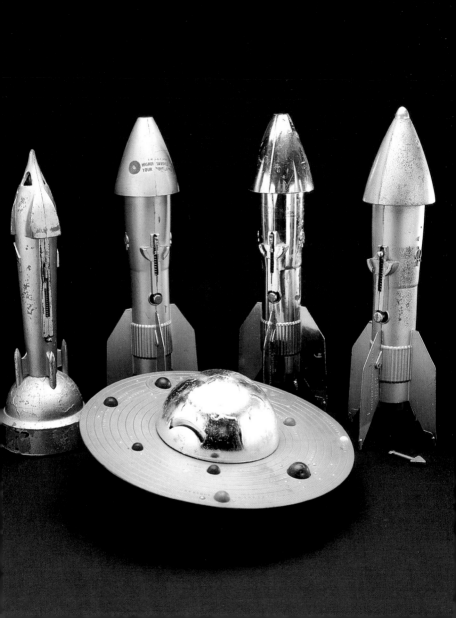

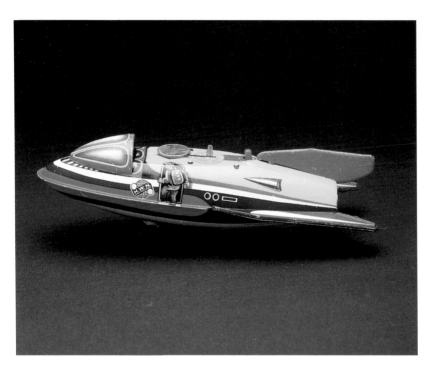

$\mathcal{G}ermany,$
1 9 5 0

\mathcal{A} lithographed tinplate toy bank.
A hinged door underneath opens with a key.

Germania, 1950
Salvadanaio giocattolo in latta litografata.
Apertura: sportello con chiave sotto la base.

U.S.A.,

J. Chein Co., mechanical tinplate toy banks:

Monkey Tips Hat. Deposit a coin in the bank and the monkey offers his thanks by tipping his hat.

Clown Chein. Press the lever and the clown sticks out his tongue, which takes the coin and deposits it inside.

Both open through a plug closure underneath.

U.S.A., 1950–60 circa

Salvadanai meccanici della J. Chein Co. Giocattoli latta.

Monkey Tips Hat. Inserendo la moneta nel salvadanaio la scimmietta alza il cappello ringraziando.

Clown Chein. Premendo la levetta il clown fa uscire la lingua che preleva la moneta depositandola nel salvadanaio.

Apertura: tappo sotto la base.

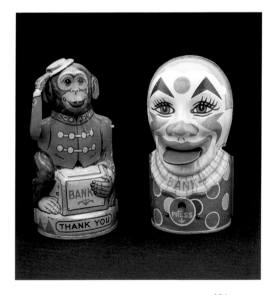

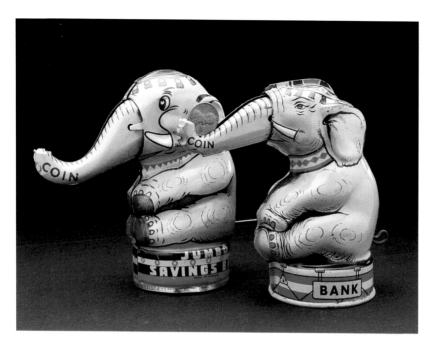

Japan and U.S.A.,
CIRCA 1950

*L*ithographed tinplate mechanical banks. Put the coin in the appropriate slot and pull the lever on the back. The elephant raises his trunk and the coin slides into the bank. Jumbo Savings Bank, Japan; Bank, Marx, U.S.A.;
Both open through plug closure underneath.

Giappone e U.S.A., 1950 circa
Salvadanai meccanici./Latta litografata. Inserendo la moneta nell'apposito spazio e tirando la levetta posteriore, la proboscide si alza facendo scivolare all'interno la monetina.
Jumbo Saving Bank—Giappone; Bank—Marx—U.S.A.;
Apertura: tappo sotto la base.

England,

𝒯inplate banks:
 Puppy painting. The coin slot is in the top of the frame. Opens with a key in back.
 Man with a drum. Insert a coin and the man's legs extend. His hat comes off to open
the bank.

Inghilterra, 1950 circa
Salvadanaio./Latta.
Quadretto salvadanaio. La fessura per introdurre le monetine è sopra la cornice.
Si apre con serratura posta sul retro.
Omino con tamburino. Inserendo le monete le gambe dell'omino si stendono.
Si apre togliendo il cappello dell'omino.

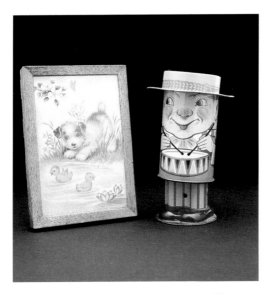

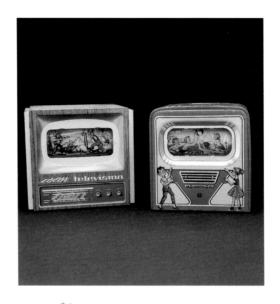

*M*echanical TV banks. Insert a coin and
the picture on the screen rotates. Hinged door opens
with a key.

Germania, 1950–60 circa
Salvadanai/televisori meccanici. Inserendo una mon-
etina gira la figura del televisore.
Apertura: sportello con chiave.

Europe,
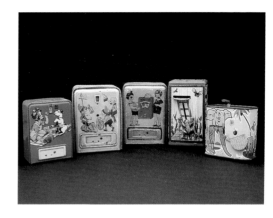

1 9 3 0 – 6 0

\mathcal{M}echanical tinplate banks: Three coin registers, Germany, 1930–50. They open when a preset total is reached. Jumping Frog Bank. The frog jumps and pushes the money into the bank. Elephant bank. Push the lever and the elephant lifts the basket containing the coin to the coin slot. Hinged doors open with a key.

Europa, 1930–60
Salvadanai meccanici in latta. Tre registratori di cassa—Germania 1930–50. Apertura: a raggiungimento cifra prestabilita sportellino con serratura.

\mathcal{L}ithographed tinplate banks used as toys, featuring fairy-tale scenes and characters. A musical mushroom. A bird house. Turn the cranck and the bird comes out, takes the coin, and deposits it inside. All have plug closures underneath, except for the book bank, which locks on the side.

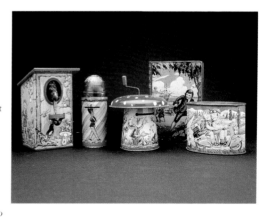

Europa, 1930–50
Salvadanai in latta litografata usati come giocattolo dai bimbi, con scene e personaggi di fiabe. Funghetto sonoro. Nido: girando la manovella esce l'uccellino, che preleva la moneta e la depone nel salvadanaio. Apertura: tappo sotto la base. Il libretto ha una serratura laterale.

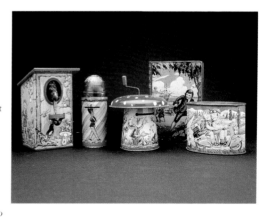

110

Germany and China,

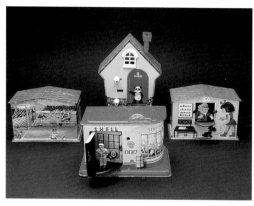

*M*echanical tinplate Banks: Germany, around 1950. Press the lever and the soccer player kicks the coin into the goal. Germany, 1950–60. Insert the coin and the gas station attendant comes through the door. China, 1960–70. Dial the right combination at the panda house and the panda's eyes light up as the door opens. East Germany. Push the lever and the banker pulls the coin inside. All have hinged doors underneath which open with a key.

Germania e Cina, seconda metà del '900

Salvadanai meccanici in latta. Germania 1950 circa. Il calciatore premendo la leva lancia la moneta in porta. Germania 1950–60. Inserendo la moneta si apre lo sportello ed esce il benzinaio. Cina 1960–70. Casetta panda; formando la combinazione giusta si illuminano gli occhi e si apre la porta. Germania Est. Banca; premendo la levetta il ripiano porta la moneta all'interno della cassa. Apertura: a sportello con chiave sotto la base.

Italy,

\mathcal{L}arge still bank. An actual 100 lire coin, about the size of a U.S. dime, is shown for size comparison.

Italia, 1956
Salvadanaio statico di grandi dimensioni (vedi proporzione nella foto con 100 Lire vere).

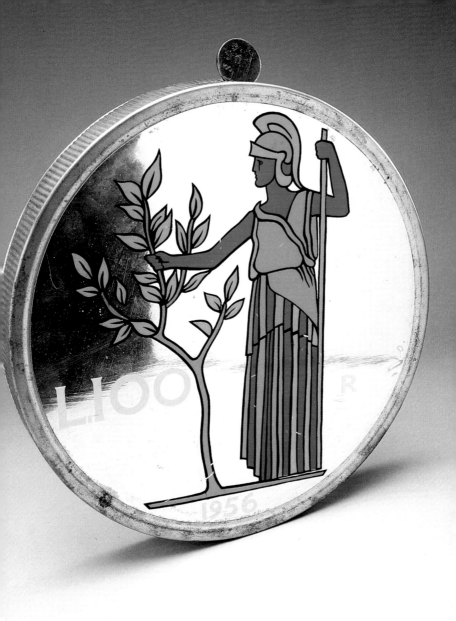

Japan,

1 9 5 0 – 6 0

*L*ithographed tin-
plate clockwork toy banks:
Coins are flipped into these
banks from their initial posi-
tion.
Coffin Bank.
Happy Hippo Bank.
Opened through a hinged door
underneath.

Giappone, 1950–1960
*Salvadanai giocattolo meccani-
ci (carica a molla). Latta
litografata.*
Dall'apposito spazio la moneta viene prelevata e lanciata all'interno del salvadanaio.
Coffin Bank. Happy Hippo Bank.
Apertura: sportello sotto la base.

Japan,

C I R C A 1 9 5 0 – 6 0

*T*axes bank of tin-
plate and plastic. Battery-
operated; the banker kicks the
coin into the top hat. Opens
through a hinged door under-
neath.

Giappone, 1950–60 circa
*Salvadanaio a batterie. Latta
plastica. Il banchiere calcia la
moneta nel cilindro. Apertura:
sportello sotto la base.*

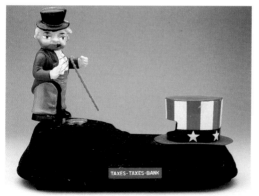

U.S.A. and Europe,
1 9 3 0 – 6 0

Still banks shaped like mail boxes.

U.S.A. e Europa, 1930–60
Salvadanai statici—raffiguranti cassette delle poste (Post Office—Savings Post).

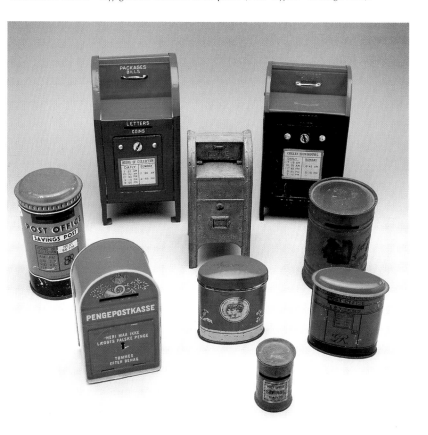

*B*anks distributed by Texan banking institutions, illustrated with Wild West scenes and characters.

The mechanical one is operated by putting a coin on the pistol and pulling the trigger so the coin knocks off the cowboy's hat and falls into the slot. Open by plug or door openings underneath.

U.S.A., fine '900

Salvadanai distribuiti dalle banche del Texas con scene e personaggi del mitico west.
In quello meccanico la moneta viene messa sopra la pistola, e premendo il grilletto,
entra nel salvadanaio facendo saltare via il cappello al cowboy. Apertura: portello e
tappo sotto la base.

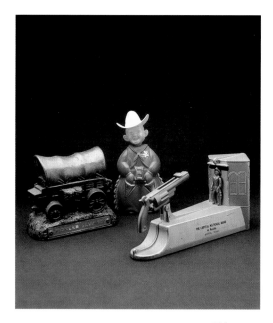

U.S.A. and Italy,

CIRCA 1950–60

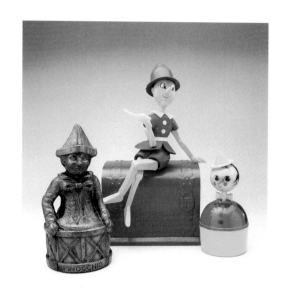

*P*inocchio banks:

Pinocchio on a drum, U.S.A., 1950, metal alloy.

Pinocchio on a strongbox, Italy, alloy and plastic.

Bakelite Pinocchio, Italy around 1960. When the coin is inserted, he nods his head in thanks.

U.S.A. e Italia, 1950–60 circa

Salvadanai raffiguranti:

Pinocchio sul tamburo—U.S.A. 1950/Lega.

Pinocchio sul forziere—Italia/Lega e plastica.

Pinocchio in bakelite—Italia 1960 circa. Inserendo la moneta muove la testa e ringrazia.

$\mathcal{U.S.A.,}$

\mathcal{P}lastic and tinplate
Disney character banks.
Plug openings underneath.

U.S.A., 1960–70 circa
*Salvadanai in plastica e latta
della Walt Disney riproducenti
i personaggi più famosi.
Apertura: tappo sotto la base.*

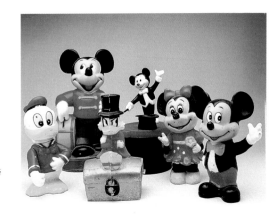

\mathcal{J}apan and \mathcal{E}urope,

\mathcal{M}ore Disney plastic
and tinplate banks, from
Japan, Italy, Germany.

**Giappone e Europa, 1960–70
circa**
*Salvadanai in plastica e latta
della Walt Disney provenienti
da: Giappone, Italia,
Germania.*

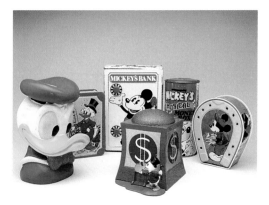

U.S.A. and Europe,

CIRCA 1950-60

*S*till banks.

Pirate chest, U.S.A., around 1950–60, metal alloy. The lid opens.

Pirate chest, Europe, around 1950–60, tinplate. Hinged door underneath.

Peg-legged pirate, U.S.A., around 1955, cast iron. Opened by unscrewing a fitting on the back.

U.S.A. e Europa, 1950–60 circa

Salvadanai statici.

Cassa dei pirati—U.S.A. 1950-1960 circa/Lega.

Si apre il coperchio.

Cassa dei pirati—Europa 1950-1960 circa/Latta.

Sportellino sotto la base.

Peg-legged Pirate—U.S.A. 1955 circa/Fusione ferro. Apertura: a vite sulla schiena del pirata.

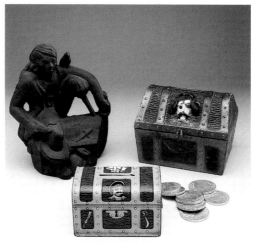

U.S.A.,

CIRCA 1950

\mathcal{U}ncle Sam mechanical bank. Put a coin in his hand and press the button: the bag opens and the coin drops in. Opens underneath.

U.S.A., 1950 circa
Salvadanaio meccanico. Uncle Sam. Mettendo una moneta sulla mano e premendo il bottone, si apre la borsa e la moneta viene depositata nel salvadanaio. Apertura: sotto la base.

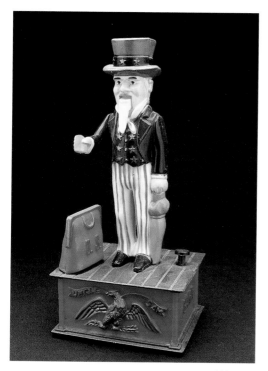

𝒥he most unusual of these are:

The professor (pink bank). His hand indicates the level of coins in the bank.

The purse. The coin slot is hidden under the purse snaps.

Kissing children (battery-operated). When a coin is inserted the children dance and kiss.

All made in plastic. Plug openings underneath.

Europa, anni '50
Salvadanai in plastica
I più particolari sono:
Il professore (salvadanaio rosa) indica con la mano l'aumentare delle monete introdotte nel salvadanaio.
Il borsellino—sotto la chiusura è nascosto il foro per inserire le monetine.
I bimbi che si baciano (a batterie)—inserendo la moneta i bimbi ballano e si baciano.
Apertura: tappo sotto la base.

U.S.A.,
1 9 8 0 - 9 0

*N*ew York souvenir banks of metal alloy.
Empire State Building.
Statue of Liberty.
All open from underneath.

U.S.A., 1980–90
Salvadanai souvenir da New York./Lega.
Empire State Building.
Statua della libertà.
Apertura: sotto la base. ➢

U.S.A.,
1 9 5 0 - 6 0

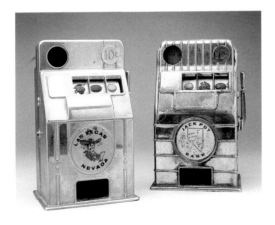

*S*lot machines of
metal alloy.
 Souvenirs of Las Vegas and
Reno. Try your luck by pulling
the lever. Plug openings in
back.

U.S.A., 1950–60
Slot Machine. Lega
Souvenir da Las Vegas e Reno.
Tirando la leva si tenta la for-
tuna con le combinazioni.
Tappo nella parte posteriore.
 ➤

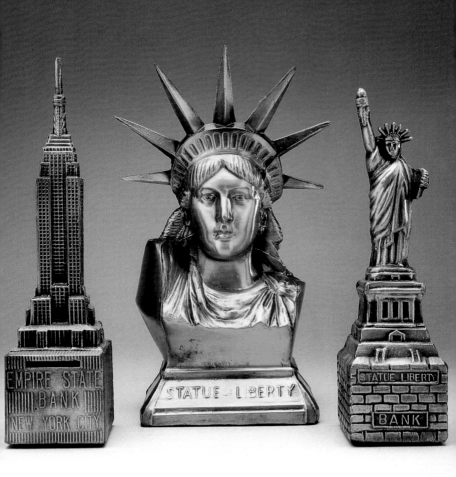

A Bit of History

*B*anks, or moneyboxes, have been widely used since ancient times by populations who created different types depending on their own needs and the customs of the age.

We find very old examples still extant from Roman excavations and ancient Greece—in fact, the ancient philosophers Plato and Cicero taught that many of life's problems could be solved by thrift and avoidance of excess and waste. In this way, they were early backers of the idea of saving. Many bank specimens, such as urns from the ruins of Pompeii, are preserved in Italian museums; presumably, these would be much less rare had they not been made of terra-cotta, a cheap and very fragile material. Of course, it is likely that many were broken by their owners to retrieve the money.

In later centuries, moneyboxes underwent many changes in both material and design, reflecting fashion, artistic tradition, and culture of time and place. In the nineteenth century, moneyboxes served a dual purpose: they served both as decorative yet useful objects for adults and as children's toys that encouraged them to save. Many

money boxes from this period were called "banks" in English or *caisses* in French, because they were shaped like the buildings that housed large banking institutions. The real banks, of course, promoted the production and distribution of money boxes.

Today, the piggy bank is very familiar and has earned a new function—as a collector's item whose value increases every day. In fact, while we once told children to keep their savings in piggy banks, today it might be wiser still to advise them to spend their savings on collectible piggy banks.

COLLECTING PIGGY BANKS

People began collecting piggy banks (especially those in ceramic) around the turn of the century. But it wasn't until the 1920s in America that the hobby really caught on. There are several categories of collectible banks: still banks, mechanical banks, registering banks, vending banks, and safes. These banks are made of a variety of materials—terra-cotta and better-quality ceramics, wood, cast iron, metal alloys, tinplate, bakelite, plastic, and papier mache.

STILL BANKS

The term "still bank" refers to all banks with just a coin slot—no moving parts. The earliest are of lower-quality materials such as

terra-cotta. They had very simple shapes (small urns, jars, and pots) and little decoration, and were simply used to hold or hide the owner's money. Later, other ceramic types with a much more attractive appearance were created, colorfully decorated with flowers or other designs. As they were very successful, more and more varieties were produced, until they became legitimate decorative items.

The most common bank shapes drew their inspiration from animals, houses, or children. Few of these have survived, perhaps in part because there was no way to open them except to break them. The still banks of this era that collectors prize most highly were produced by the most famous ceramic manufacturers, such as Royal Doulton, which was founded in England in the early 1800s.

The collection of still banks developed significantly in the late nineteenth century. Collectors were most interested in metal models, whether of iron, tinplate, or alloys. The varied shapes of these banks were inspired by the tastes and fancies of the day; they depict famous personalities (George Washington, Benjamin Franklin, Queen Victoria, etc.) or characters from stories and comics, commemorative events, or good-luck mascots (the golliwog, Transvaal, The Capitalist, Mutt & Jeff, Billiken). The growing popularity of these objects received a tremendous boost from commercial banks, which specially commissioned many designs (strongboxes, bankbooks, and various containers) to encourage people to open savings accounts and advertise the bank's services.

In Italy in the 1930s and 1940s, banks and insurance companies played an important role in furthering the popularity of money-boxes by distributing chests, metal bankbooks, and alarm clocks that ran by inserting a coin a day. Other businesses also gave out still banks to advertise and promote sales. In fact, a number of products (especially cookies and candies) were packaged in ceramic or tin containers that could be used as banks after they were emptied. Such objects became very common, and fine-printed or lithographed period examples can still be found today. Other common objects upon which banks were modeled were a cottage with a thatched roof, a doll's house, Transvaal Money Box, and figures or symbols such as a baseball player, baby in a cradle, golliwog, Mutt & Jeff, and the Liberty Bell. Other still bank models were actual toys made of a number of different materials—metal, tinplate, bakelite, and plastic—and bore the trademarks of some of the most famous toymakers in the world.

These often featured characters from cartoons (Mickey and Minnie Mouse, Donald Duck, Bugs Bunny, Yogi Bear) or fairy tales (Pinocchio), as well as folk characters (Santa Claus and La Befana, the Italian bringer of Christmas presents).

MECHANICAL BANKS

These banks have mechanical movements, and all work more or less in the same way: a coin is placed in the appropriate position and

a mechanism is triggered to deposit the coin inside. This type was extremely popular in North America, where the principle of saving was very strong. Such banks became the symbol of progress and a highly regarded present for children. Precisely because of this popularity, a large number of models were developed, creating not only a flourishing industry but an enthusiastic body of collectors. The competition among American collectors has increased the value of some models immensely, in contrast to mechanical banks in Europe, where the hobby of collecting such objects is still relatively undeveloped.

The first known and patented mechanical banks date from the early nineteenth century, but production only really took off around the middle of that century. Most examples were made of hand-decorated cast iron. The finest banks were made between the 1870s and the early 1900s; the best known are Hall's Excelsior Bank, Tammany Bank, and the infamous Jolly Nigger Bank and Dinah Bank.

The most highly prized banks today are those with the most sophisticated mechanisms, or those depicting famous or memorable events.

In the early 1900s, tinplate was introduced as a material for mechanical banks. The first producers were the Germans, who invented a large number of low-cost models with simple mechanisms—thus encouraging their success. Toward the 1930s, the English and Americans also started producing this type. Although very fragile compared to cast iron, tinplate had the great advantage of lower manufac-

turing cost and lighter weight, together with a wider range of options for distinctive shapes and printed designs.

Many tinplate banks were imprinted with a patent registration number, which today helps identify models and increases their value to collectors. The most interesting were made in Germany from 1920 to 1930 and depict people, animals, and cartoon characters. All of them tend to have similar lever-operated mechanisms (an opening mouth or protruding tongue, for example) to move the coin inside. The most highly prized today include banks featuring Mickey Mouse, Harold Lloyd, Minstrel Type I/II, Jolly Joe Clown, and the Scotchman. American and European models of particular interest include London Tower, Dapper Dan, the Magic Bank, Monkey & Parrot, and Monkey with Tray. More common but no less desirable are the Clown Chein, Monkey Hat, and Calumet Bank. In the 1960s and 1970s, many mechanical banks were inspired by the fantastic adventures of comic-book characters such as Flash Gordon and the conquest of space. These varieties often depicted spaceships, rockets, satellites, and commemorative images, forming a category all their own for the specialized collector. Relatively few mechanical banks were made in Italy; the most common were those made in the 1940s by insurance companies, which distributed clocks ran that for twenty-four hours on a coin.

\mathcal{L}ike cash registers, these banks record the total value of the deposited coins. Some offered a mechanism that automatically unlocked the bank at a preset total so money could be taken out. Certain models, such as Uncle Sam's Three Coin Registering Bank, were in production for many years. Uncle Sam sold first in 1912 and still enjoyed widespread demand more than fifty years later. Register-ing banks were extremely popular in Europe, and many German and Northern European examples exist from before World War II. The most unusual and interesting, today much sought after by collectors, are those made of cast iron: the Perfection Registering Bank, Chromo Heater Bank, Pump Reg. Bank, and The H. and H. Reg. Saving Bank (dime-cent-nickel). Other tinplate examples from 1920 to 1950 include the Daily Mail Silver Bank, Codeg Magic Money Box, Auto on Road, Ocean Liner Reg. Bank and Elver Roller Coin. These were immensely successful as children's toys. Banking institu-tions also gave out many kinds of registering banks, usually in the shape of a small tower. The inserted coins could be counted by looking through a little slot marked with graduated values.

\mathcal{I}nserting a coin into one of these banks triggers a mechanism that allows an object or piece of candy to be removed. They were made primarily by candy companies, who distributed them to promote their own products. The finest were made between 1910 and 1930, mostly in Germany and France. The best-known maker of this type of promotional bank was Stollwerck Brothers, which produced the splendid Stollwerck Victoria type (Automatic Saver, Progressive Sampler, the Postman, and Red Riding Hood).

Other candy companies that used the same type of promotion were Pascal, Nestle's Milk Chocolate Co., Droste, and Huntley and Palmers. Almost all these banks were colorful, decorated with exquisite designs depicting fairy tales or children at play. One of the loveliest was made in France by L. Revon & Cie Chocolat Menier, in the form of a typical Parisian advertising kiosk. Many toy companies also produced vending machines: Bing, Märklin and Lehamann. These vending banks are keenly sought after by toy and piggy bank collectors.

S A F E S

\mathcal{M}ade of cast iron or nickel-plated metal, safes had a sturdy appearance and resembled their full-sized counterparts. They were usually embellished with delicate, elegant ornaments and decorations and had key or combination locks. This type of bank was first produced late

in the nineteenth century, and two of the most interesting models are the Fidelity Safe (Kyser & Rex Co., 1880) and the Kodak Bank (J. & E. Stevens, 1905). Of course, a great many models were put on the market during this period, and they underwent transformations in both material and shape as time went on. Eventually, more colorful toy safes, designed to resemble children's games, were made out of plastic or tinplate. Even today these safes are considered archetypal examples of the toy savings bank.

THE MOST IMPORTANT MANUFACTURERS

*I*n the beginning, the most important piggy banks makers were foundries, which started producing them in response to popular interest. In some cases, these foundries eventually shifted their efforts to making piggy banks and toys exclusively.

ARCADE MANUFACTURING COMPANY, U.S.A.

This company began producing piggy banks late in 1880. Its first patent, for the Bank of Columbia, was filed around 1891. The company's slogan was "They Look Real," and, thanks to an enterprising manager, Arcade made numerous deals with major firms (such as Chicago Taxi Co. and General Electric) to produce promotional banks. This strategy carried the company through the Depression. After World

War II, Arcade was sold to Rockwell Mfg. Co., and its trademark soon disappeared from toys and banks.

BANTHRICO INC., U.S.A.

This extremely successful company, founded in 1931, was among the first to produce plastic penny banks. Thousands of units were put on the market and became highly successful, particularly in the wake of the commemorative bank made for the First National Bank of Chicago. From that point on, the company dedicated itself to making toy banks for financial and banking institutions, most of cast zinc-aluminum alloy. Banthrico still actively manufactures and exports banks today; since the 1960s they have been easy to recognize by their Banthrico trademark.

J. CHEIN COMPANY, U.S.A.

This company entered the market in the early 1900s, with some sixty-five to seventy different models of toys and banks, all of colorfully lithographed tinplate. The best known were the Child's Fireproof and Mascot Safes, brought out around 1906. The company's production was shut down during World War II and resumed afterwards with many new designs. One of its particularly interesting banks is a globe, first marketed before 1934 and last produced in 1977. Other well-known

models include the tinplated Clown Chein Bank, which sticks out its tongue to take a coin when a lever is pulled, and the Monkey Tips Hat Bank, which features a monkey doffing its hat to acknowledge the deposited coin. The company left the toy and bank business in 1977.

JOHN HARPER & CO. LTD., ENGLAND

Founded in 1790, John Harper was the most famous maker of cast-iron still and mechanical banks. The most well-known were the Wimbledon Bank, Giant in Tower Bank, Hoopla Bank, Tammany Bank, Jolly Nigger Bank, and Dinah Bank. The company's last bank was the Crown and Throne Bank, brought out in 1953 to commemorate the coronation of Queen Elizabeth II. John Harper virtually halted production of cast-iron banks after World War II because of the iron shortage.

THE HUBLEY MANUFACTURING CO., U.S.A.

Founded in 1894 as a toy factory, this company soon became one of the most famous in the country for producing banks. It made a great many banks, including Santa Claus Bank, Rabbit Bank, Foxy Grandpa Bank, Small Elephant Bank, Trick Dog Bank, Monkey Bank, Elephant Pull Tail Bank. Like so many others, Hubley was forced to interrupt production during the war, for lack of raw material.

KYSER & REX CO., U.S.A.

Founded in 1879, Kyser & Rex produced both still and mechanical banks. The two founders after which the company was named were also inventors, and they made wonderful, ingenious models. Their finest still banks made up a splendid line that included the Globe Saving Fund and Coin Registering Banks. Noteworthy mechanical banks included the Bowling Alley Bank, Organ Bank, Mammy and Child Bank, Mikado Bank, Lion and Monkey Bank, and Merry-Go-Round Bank.

The company was short-lived, for its founders soon parted ways. It closed down in 1898.

SHEPARD HARDWARE CO., U.S.A.

One of the largest foundries in the U.S., Shepard started producing mechanical banks in 1882. Its many designs were very successful and became widely popular. Unfortunately, the company closed in 1892 because the founding partners, the Shepard brothers, split up and went on to other activities. Some of their most important creations were the Jolly Nigger Bank, Humpty Dumpty Bank, Punch and Judy Bank, Trick Pony Bank, Uncle Sam Bank, Stump Speaker Bank, and Trick Dog Bank. Others, much sought after, are the Picture Gallery Bank, Speaking Dog Bank, Mason Bank, Circus Bank, Santa Claus Bank, Jonah and the Whale Bank, and Artillery Bank.

J. & E. Stevens Co., U.S.A.

Founded in 1843 as one of America's oldest toymakers, this company made a number of valuable piggy banks. The first known example, Hall's Excelsior Bank, dates from 1870, and was followed shortly by Hall's Lilliput Bank. Toward the end of 1890, the success of these products led Stevens to concentrate exclusively on the production of toys and piggy banks. Among its finest were the Horse Race Bank, Tammany Bank, Cupola Bank, William Tell Bank, Novelty Bank, Bank Teller Bank, Magician Bank, Bird on Roof Bank, Creedmoor Bank, Bulldog Bank, Owl Bank, Puddy & the Pig Bank, and Clown on Globe Bank. Stevens, too, had to suspend activities during World War II for lack of raw material.

A.C. Williams Company, U.S.A.

This company began operations in 1872 and had produced its first banks by the early 1900s. Its production of banks started almost by chance, when a client, charmed by the samples used by sales representatives, suggested selling them as toys. Williams patented many very successful models, including the Skyscraper Bank and Two-Faced Indian Bank. This company was among the largest producers of still banks in the most diverse varieties: animals, ships, mailboxes, buildings. It too had to stop production for lack of iron during the war, and resumed only to make toys (until 1977); it never made banks again.

Prospective collectors of piggy banks should be very wary of fakes and reproductions of the most famous pieces.

In the early 1970s, a great many reproductions were made with the same characteristics as the very valuable originals. Beware, for these copies are mere gadgets or souvenirs, much less expensive and valuable than their antique predecessors. Taiwanese models are particularly common all over the world, and they differ from the originals only in small details such as dimension (the authentic banks are generally larger) and color (the replicas are brighter, less subtle).

Early copies were stamped "Made in Taiwan" on the base, making them easy to recognize. But since this stamp can easily be obliterated with plaster or gesso, the piece can be sold as an original at a high price. Another trick is to age the product artificially by repainting it and treating it for wear and oxidization. The result is a false antique patina.

Today reproductions are still being made, but the stamp on the base has been replaced by a little sticker. Experts can also detect copies by the low quality of the materials, which may make them poorly detailed or porous. They may also be crudely assembled with Phillips-head or other modern screws (which can be replaced or drilled through to mimic originals).

Certainly, once you have had the opportunity to see an original bank, you will immediately recognize how different it is from a copy in

both weight and quality of the casting material, as well as coloring and detailing. Remember, at one time they were all made by hand. Another important point of reference for recognizing original models is the patent registration number. Many had these stamped on the underside.

The most commonly reproduced banks are the Artillery Bank, Boy Scout Camp Bank, Bulldog Bank, Creedmoor Bank, Darktown Battery Bank, Dentist Bank, Dinah Bank, Humpty Dumpty Bank, I Always Did 'Spise a Mule Bank, Jolly Nigger Bank, Jonah and the Whale Bank, Monkey Bank, Owl Bank, Puddy and the Pig Bank, Teddy and the Bear Bank, Transvaal Bank, Trick Dog Bank, Trick Pony Bank, Uncle Sam Bank, and William Tell Bank. To start your collecting on the right foot, it would be very much worth your while to consult books on the subject by Bill Montan, Al Davidson, Robert L. McLumbert, and Andy and Susan Moore. These very useful works illustrate a large number of banks, pointing out their most distinctive details and describing their operation. All are of significant interest to the collector.